IMAGES
of America

MINT HILL

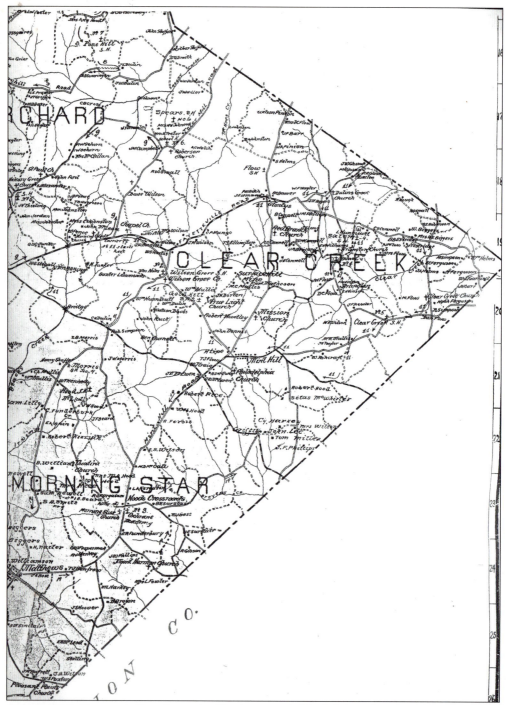

C.A. and J.B. Spratt, civil engineers in Charlotte, probably didn't realize the 1911 postal map they compiled would one day be a valuable resource for historians. This small section of the Mecklenburg County map reveals landowner names, location of houses, both African-American and white schools, churches, stores, roads, creeks, bridges, and the route for the delivery of mail.

The Mint Hill Historical Society

Copyright © 2005 by The Mint Hill Historical Society
ISBN 0-7385-1815-8

Published by Arcadia Publishing
Charleston SC, Chicago IL, Portsmouth NH, San Francisco CA

Printed in Great Britain

Library of Congress Catalog Card Number: 2005922445

For all general information contact Arcadia Publishing at:
Telephone 843-853-2070
Fax 843-853-0044
E-mail sales@arcadiapublishing.com
For customer service and orders:
Toll-Free 1-888-313-2665

Visit us on the internet at http://www.arcadiapublishing.com

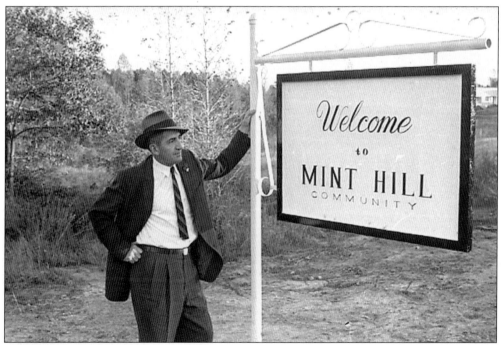

Robert Quillen was an instrumental leader of the Piedmont Area Development Association (PADA). This 1958 sign, noted as the only of its kind in the county, reads "Welcome to Mint Hill Community" on one side and "Welcome to the Clear Creek Community" on the other.

Contents

Acknowledgments 7

Introduction 8

1. People and Homes 9
2. Business and Community 65
3. Schools and Churches 99

The Mint Hill Historical Society became a reality under Becky Griffin's leadership. She spearheaded the relocation and restoration of Drs. J.M. DeArmon and Ayer Manny Whitley's office building, now the Mint Hill Country Doctor's Museum, a Mecklenburg historic site. She also helped relocate and restore the Ira V. Ferguson Country Store at the same site. The Ashcraft schoolhouse and meat curing building, Wilson Assay Office, Beaver Barn, and welcome center are part of the plans of the Carl J. McEwen Village—all under Becky's direction. As a member of Altrusa Club of Charlotte, she received the Woman of the Year award in 1997 for "helping to establish the MHHS and for her work in spearheading the move of the Country Doctor Museum." In April 2001, she was nominated by the mayor and recognized by the Mint Hill Board of Commissioners for the Mint Hill–Matthews Rotary Club's Mint Hill Citizen of the Year Award. Becky once said, "It will be a sad day when I don't have an idea or dream for the future. My mind constantly churns with new plans for the Historical Society, for the church, for our business, for the family and for myself. That's what makes my heart sing."

Bettie McEwen was a MHHS charter member who served as treasurer as long as her health allowed. When the question arose about where to move the old doctors' building, she encouraged her family to donate land on Hillside Drive. The land that the Carl J. McEwen family donated became the keystone of the historic village. Bettie was a generous supporter of many causes in Mint Hill, but her influence extended into the Greater Charlotte area and beyond. She was instrumental in establishing the McEwen Scholarships at UNC-Charlotte, served on the Charlotte-Mecklenburg Hospital Authority, and was active in the Altrusa Club of Charlotte for more than 50 years. A life-long member of Philadelphia Presbyterian Church, she was the first woman elected deacon and served as the treasurer for many years. She graduated from Bain School and Peace College and served in the Women's Army Corps during World War II. A Mint Hill native and lifelong resident, Bettie was the daughter of Carl J. and Minnie Belle McEwen. She died at age 83 on December 20, 2004.

Acknowledgments

Twenty years ago, a group of 21 people gathered to become the charter members of the Mint Hill Historical Society. We acknowledge and appreciate their purpose and passion to find, restore, and preserve our history. The 21 members who signed the charter on April 30, 1985, are Becky Griffin, Minnie Lemmond, June Baucom, Lynn Rhodes, Amelia Ford, Martha Strohm, Jim Black, John Black, Maxine Chrosniak, Russell Kerr, Nancy Kerr, Robert Venn, Margaret Welch, Carol Timblin, Steve Ross, Bettie McEwen, Ruby Smoak, Becky Hamilton, Marti Wyatt, Joan Bayer, and Tony Johnson.

From beginning to end, Suzanne Lee McDonald, administrative director of the MHHS, has been the driving force behind this project. Her quiet, generous enthusiasm and pleasant insistence made this an educational and enjoyable endeavor. She never asked more volunteer hours from members than she herself was willing to give.

Special recognition is extended to Melissa Yarbrough, a Girl Scout from Troop 202, who first conceived the idea of asking the citizens of Mint Hill to bring photographs of their families, local schools, churches, and businesses to the Mint Hill Public Library to be recorded and scanned into our archives. The event was publicized giving everyone a chance to participate.

A committee consisting of Judy Houston McRorie, John Black, Ruth Miller Hood, Suzanne McDonald, Evelyn Henderson Allen, and Jeanette Phillips Driggers met weekly for almost two years organizing, sorting, and identifying photographs and gathering historical information. Many others shared time, knowledge, and advice.

Finally, the book was ready to be put in production format. A team consisting of Becky Junker Griffin, Suzanne Lee McDonald, Katherine Luna McKeever, Judy Houston McRorie, Carol Lowe Timblin, Cathy Lynn Davis, and Shirley Phillips West, some of whom literally burned the midnight oil, worked to complete the assignment. Captions needed to be written and photographs were placed page by page. The facts and stories are written as told to us. While we have endeavored to check all information, some errors will be made. We apologize and ask that you please bring these to our attention.

We acknowledge with deep gratitude, the following who have served as president of the Society: Carol Lowe Timblin, Frank Lindsay, Rev. Martin Kerr, Shirley Phillips West, Peter Larsen, Van Dolan Moore, Jane Burdick ,and our present co-presidents Jerry and Sue Lemmond Helms.

The Mint Hill Historical Society office is located at 7601 Matthews-Mint Hill Road. We invite you to visit us and enjoy the Carl J. McEwen Historic Village, which currently includes the Dr. Ayer Whitley Country Doctor Museum and the Ira V. Ferguson Country Store Museum. The Ashcraft one-room schoolhouse and Ashcraft meat curing building are on site and under restoration. Future restoration plans include a log barn and a gold assay office.

Introduction

In honor of the 20th anniversary of the Mint Hill Historical Society, the trustees and members proudly make this photo album available for the enjoyment of the citizens and friends of Mint Hill. Our hope is that these pages will provide a glimpse into the lives of a few people and some events that have shaped our community, as well as inspire readers to recognize the value of recording history.

Early history tells us that John Rogers was the first white man to settle in the Rocky River area of what was to become Mecklenburg County. Just as the Indians had found the area good for camping due to the many creeks and streams so did our early settlers find the area a delightful place to begin their new lives. The availability of large tracts of land, rich soil, and mild climate made the area ideal for settlement. From these early pioneers, came people of great patriotic and religious temperament. Adam Alexander, John Foard, and John Query represented our area as signers of the Mecklenburg Declaration of Independence. The Clear Creek Militia had among its ranks the ancestors of many of today's citizens and our earliest churches date back before the Revolutionary War.

While the early settlers relied on their own industry to provide for their basic needs, soon blacksmiths, tanners, wheelwrights, and merchants appeared. With the invention of the cotton gin and a railroad station at Allen, raising and shipping cotton became more profitable. Of course, not to be overlooked was the mining for gold. Each century has brought diversity in people, industry, education, and religion.

Almost 300 years of history is much more than can be captured on the few pages allowed in this book, the historical society continues to endeavor to preserve the history of the area through oral history, preservation of buildings, and archiving of pictures, records, and artifacts. The pictures and information as written within these pages have been provided by many of our citizens. And, as in any effort to record history, errors will be made. If you find this to be true please make us aware of any errors and allow us to correct our archives.

One
PEOPLE AND HOMES

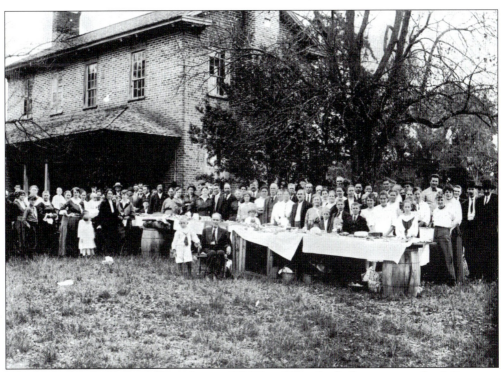

A chiseled chimney stone tells us that in 1786 David Kerr built this two-story brick home on what is now Arlington Church Road. Believed to be one of the oldest homes in Mecklenburg County still used as a residence, it includes the original four-room brick structure. Eli Hinson once owned the home and is seen here at a family reunion.

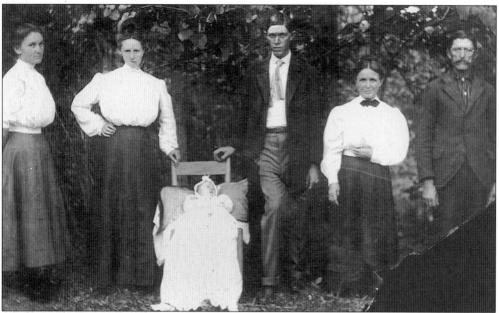

William "Sandy" Linker, a Mint Hill sheriff, was one of ten children belonging to Tobias and Mary Biggers Linker. He married Alice Elizabeth Wilson, and they had two children, William "Willie" and Lillian. Willie ground corn for the public at his gristmill. With help from his son Walter, Willie moved the Ashcraft schoolhouse from Brief Road to Fairview Road for use as a barn. Pictured c. 1910 from left to right are Lillian, Mary (married to Willie), baby Claude (son of Willie and Mary), and Alice and Sandy Linker.

Viola Helms Dorton ran the Pinecrest Florist from the Lawyers Road home she shared with her husband, Ned Dorton, assistant postmaster in Charlotte. Ned recalled that his father and others dug graves on a daily basis for victims of the 1918 flu epidemic. Ned and Viola's children are Barbara Dorton Taylor, Kay Dorton Hough, and Sarah Dorton Threatt.

We can only imagine the significance of the rolled pant legs as these four Mint Hill friends posed for this picture around 1912. Shown from left to right are (seated) Sylvester Estridge and Wilson P. Ashcraft; (standing) Perry A. Davis Sr. and Clinton M. Black Sr.

This 1928 portrait, made at the request of a Charlotte newspaper, shows four generations of women who grew up in Mint Hill. Pictured from left to right are Margaret Lillian Morris Henderson, Cora Alice Biggers Morris, Margaret Evelyn Henderson Allen, and Sarah Jane Hood Biggers.

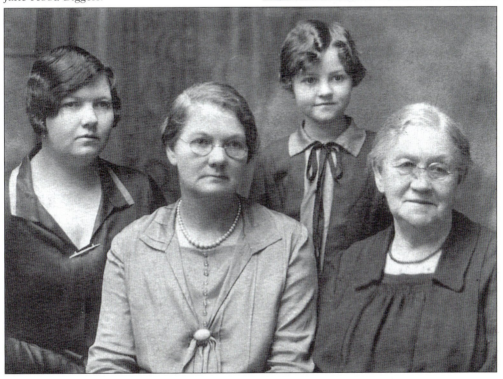

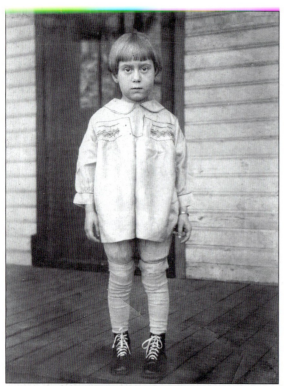

Martha Hood, the only child of Clara Wilson and Lester Hood, stands on the porch of their home on Matthews–Mint Hill Road. About eight years old when the picture was made, this "daddy's girl" often followed her father to the fields and filled her own bag with cotton. Martha married Haywood Presson, and they lived with their son, Johnny, in the home built by Johnny's great-grandparents, Abraham Smith Wilson and Martha Jane Tomberlin Wilson.

A timber on the front porch of the Crawford Biggers home reads, "This house started September 6, 1916." According to records, the total cost of the house was $500. Out of that sum, four carpenters were paid $1.25 per day to frame the home. Paul Nelson and wife, Juanita McManus Nelson, bought the home from Ike McManus. Mrs. Nelson called the house Mintwood, a name that the surrounding neighborhood later adopted.

Often called the founding father of modern-day Mint Hill, John M. McEwen (1905–1984) was instrumental in drafting an incorporation charter that would make Mint Hill a town. He also served as mayor until an election could be held. In 1982, he and his wife, Eva Scott ("Scottie"), donated the land for the construction of the present town hall where the John M. McEwen Assembly Hall was named in his honor. As a Mecklenburg County commissioner, he helped bring better roads to the area.

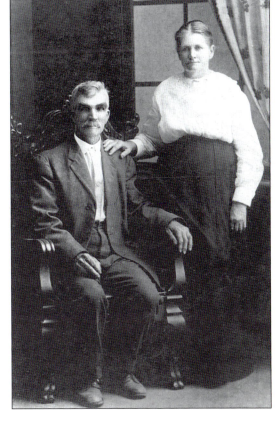

Thomas Ashcraft, who came to the Mecklenburg area in 1760, was one of three brothers who received a large land grant from the king of England. Walter Ashcraft (1859–1926) inherited several hundred acres of that land around Brief and Fairview Roads. A farmer and family man, he recognized the importance of schooling, though he himself did not have a formal education. In the late 1800s, Walter and his wife, Amanda Miller, built the Ashcraft Schoolhouse on Brief Road.

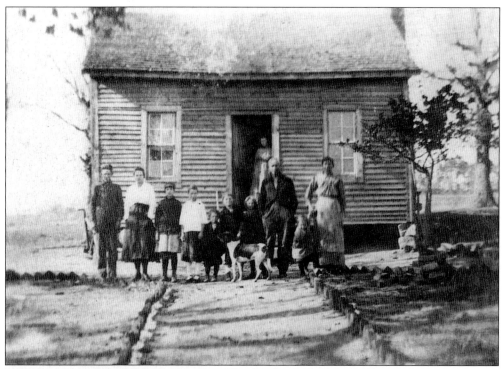

The family of Abraham Miller McCall (1868–1928) gathered in front of their home on what is now Blair Road for this picture. Shown from left to right are William Lawrence McCall (1903–1975), Virginia Bell McCall Stegall (1901–1978), unidentified, Bessie Mae McCall Fink (1905–1980), Albert Jackson McCall (1912–1980), Grant Franklin McCall (1908–1932), Amanda Mariah McCall Bartlett (1910–1978), Abraham Miller McCall (1868–1928), Essie Matilda McCall (1915–1936), and Margaret Jane Wilson McCall (1874–1945). An unidentified visitor stands in the doorway.

As an employee of Alabama Power and Light, James "Jim" McWhirter, pictured in the lineman uniform, worked on the first cross-country power line while his wife, Zelma Brafford McWhirter, remained in Mint Hill with their small children, Henrietta and James. Soon after Jim's return, baby Johnsie was born. Jim was a farmer, but once a year, he worked for Mecklenburg County as a "Tax Lister." Residents in the Clear Creek Township reported to Jim their holdings of land, animals, farm equipment, and automobiles. These properties determined the tax levied by the county.

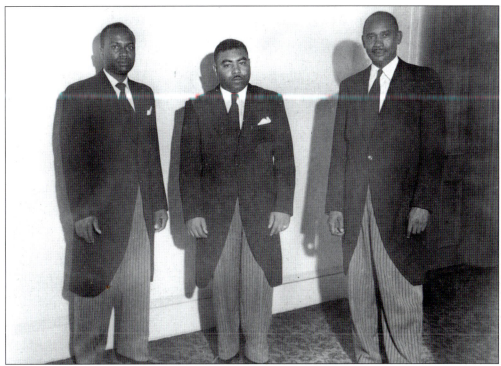

Pictured from left to right are Lemuel Long Jr., Clarence Bellamy, and Beamon Long. These young men were serving apprenticeships at McEwen Funeral Home in Mint Hill when World War II began. Lem joined the army and served in Burma until his discharge in 1945. He went back to work at McEwens until 1947, when he, William Aery, and Beamon Long bought a portion of the McEwen establishment. They eventually moved their business to Charlotte. Lem was active in civic affairs and with his church.

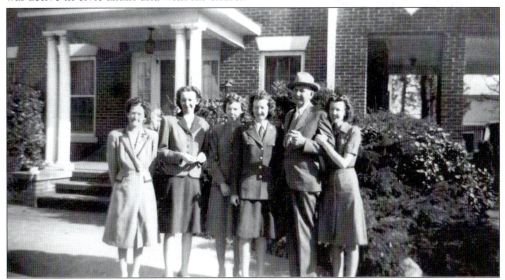

The family of Carl J. McEwen posed for this picture in front of the Mint Hill McEwen Funeral Home, which he built in 1936. Shown from left to right are Minnie Belle Mann (wife of Carl); daughters Frances, Mary Edna, and Bettie; Carl J. McEwen; and daughter Helen.

This picture of the W.A. Garland family was snapped at a 1954 gathering at their Mint Hill home. Pictured from left to right are (front row) Ronnie Stikeleather, Queen Victoria Garland, and Sonny Ross; (middle row) Vicylee Garland Stikeleather, Bessie Garland Lyman, Mildred Russell Garland, Ike Garland, Blanche Garland, Ramelle Garland, Vickie Garland, Shirley Ross, and Gail Garland; (back row) Ted Lyman, Bill Stikeleather, Hazel Garland, Lucille Shoupe Garland, Brill Garland Ross, Hugh Ross, Dub Garland, and Hurley Helms.

Dan and Avery McConnell Hood, devoted to their family and community, purchased a 200-year-old family farm in 1939 to start a dairy. Interrupted by World War II, they worked for the "shell plant" manufacturing munitions and for the county Department of Social Services. After the war, the couple filled a gap in services by providing refuge for juveniles in the court system. The Hood family still owns the property on Dan Hood Road.

Bryan Lee Houston, the oldest of three children born to Florence Blackmon and Henry J. Houston, was just six months old when he survived the flu epidemic of 1918, which killed hundreds in Mecklenburg County. He attended Bain High School and graduated as valedictorian in 1936. In 1946, he purchased the historic brick plantation (the 1786 Kerr house) and for many years raised a large herd of dairy cattle on the farm.

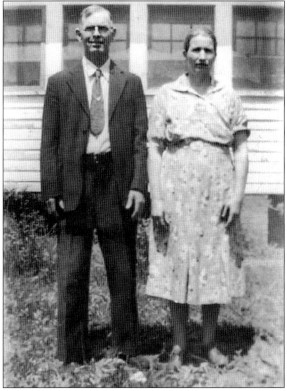

Married around the turn of the century, John Zemmeron "Zem" Benton and Emma Crump Benton built a home on Matthews–Mint Hill Road for their family of 12. Zem borrowed medical books from Dr. Ayer Whitley, a neighbor, and discussed with him the treatment and care of animals. Because of Zem's skill and knowledge, he was called Doc Benton and served as Mint Hill's veterinarian.

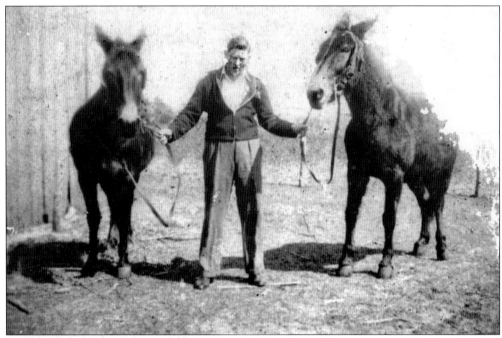

George Coolidge Houston, the son of Daniel Jefferson Houston, is shown here with his mules Blue and Bill. Located on Bartlett Road, the Houston home place was in the path of I-485 and was therefore taken by the state.

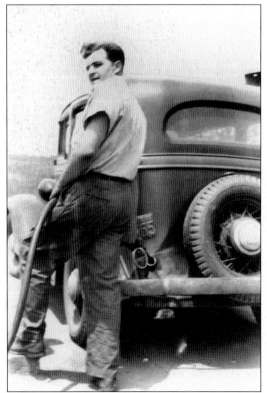

Phillip E. Bartlett, oldest son of Lawrence and Rachel Bartlett, is shown here pumping gas at the Lawrence B. Bartlett Store. During the 1940s, he and his wife, Marjorie, ran the store before he joined the Mecklenburg police force. He died while serving as Mecklenburg County police chief.

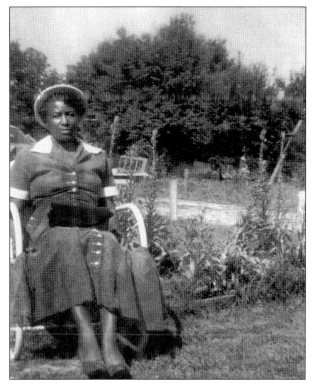

Avery Amarillis Nixon Black is shown in front of her apple and peach orchard near her home just outside of Mint Hill around 1900. Avery was known as a street peddler in uptown Charlotte, where she sold the succulent fruit from her orchard. She and her husband, Harris Jerome Black, raised eight children: Elizabeth Black Miller, Milton Black, Willie Ruth King, Louella Black Morrow, Aaron Jerome Black, Mable Black Byrum, Nathan Black, and Dorthea Black Davis.

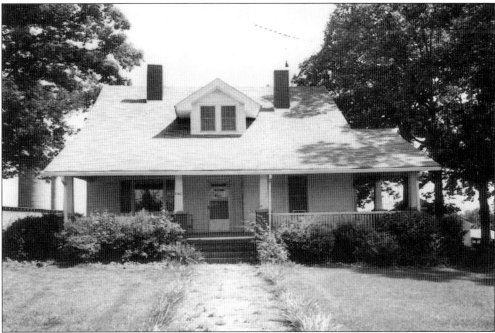

Three generations of the James Morrison Black family have occupied this Fairview Road home, built by James and Julia Campbell Black in 1904. Their son Dolph Black married Mary Billingsley; his family lived in the house while he ran a dairy farm. Dolph and Mary's son Larry and his wife, Ginger, presently occupy the home.

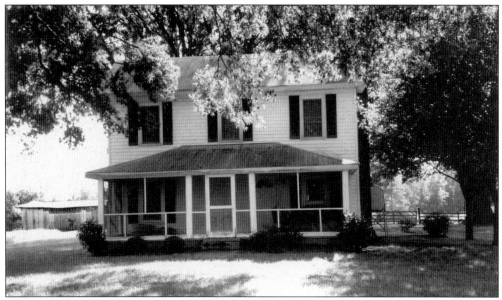

Robert Long built this home on his 200-acre farm in 1868. The youngest of seven children, Robert's grandson Zeke Long was born and raised here, and when he married Morrow Bradley Barr (1918–2001), they made this their home. With only a few conveniences added for comfort, Zeke continues to farm the land and tend the cows at this beautiful, historic two-story farmhouse. In 2003, Zeke was awarded the second Annual Preservation Award given by the Mint Hill Historical Society (MHHS).

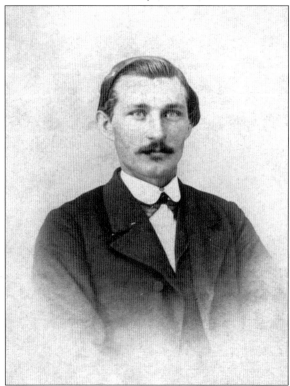

Two of Mint Hill's first families were united when Hampton W. Black (1809–1884) married Elvira McCombs (1818–1850). Shown here is their son William Hampton (1850–1926), who married Frances Morrison (1846–1933). Their two sons were James and Clinton. James married Julia Campbell, and they had two sons, Dolph and Bill. Clinton married Annie Wallace, and they had two sons, C.M. and James. Materials from the Hampton Black home have been used in restoration projects by the MHHS.

The Brafford sisters, all properly dressed with gloves, hats, and pearls, grew up near Arlington Baptist Church in the Clear Creek area. Zelma (standing at left) married James McWhirter, and Jessie (seated left) married Joseph Estridge. Both were accomplished seamstresses. Jessie worked in New York City, and Zelma worked at Montaldo's in Charlotte. Verda (standing at right) married James Conner Flowe, and Clemmie married Luther Jefferson James.

As a child, Raphael Cuthbertson rode the bus with a painted black top (for black children) to Henderson Grove School. His parents, Banks and Estelle, were proud of their son, who excelled in his studies at Clear Creek High School. Raphael was selected to tour England and Wales with the Farm Youth Exchange program while he attended the North Carolina Agricultural and Technical State University. In 1955, Raphael entered the army and retired as a lieutenant colonel in 1975. Married and the father of six sons, Raphael now resides in Charlotte.

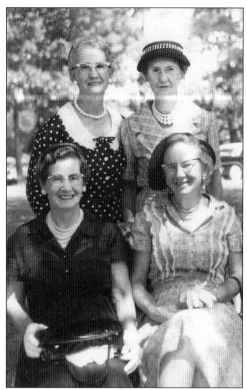

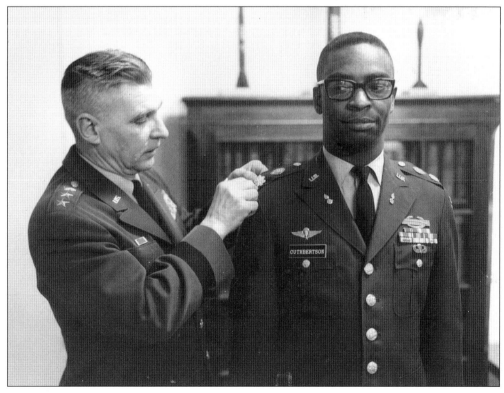

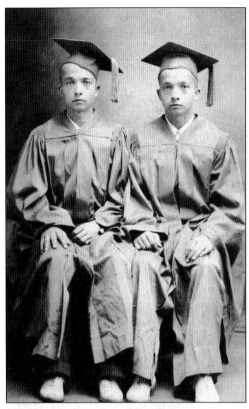

Twins Thomas Baxter Bowen and Dexter James Bowen, born to Annie Mae Bartlett Bowen on November 9, 1919, graduated from Bain High School in 1937. They lived in the house built by their grandfather Thomas L. Bartlett, which now serves as the Mint Hill Historic Society office. Their great-grandfather, James Henry Bartlett, was a Civil War veteran.

Both college-educated, Clayton Kuck and his wife, Ola Davis Kuck, loved animals and children. Robert Kyle, a foster child whom they reared from infancy, was especially dear to them. A dairy farmer, Clayton served as a standing member of the Bain School Board of Education. Ola was a schoolteacher during the 1920s.

Pictured here is Bettie McEwen, who served in the Women's Army Corps from 1943 until 1946. She joined the McEwen Funeral Home in 1947 and was president and treasurer at the time of her retirement in 1980.

Annie Hargett (1857–1939), pictured here, and her sister, Becky Hargett (1863–1938), who grew up in the Hoods Crossroads area, were just teenagers when they began their practice as midwives. They often worked with Dr. DeArmon in the Mint Hill community. Whether delivering babies or caring for the sick, these midwives would come night or day and often stayed in homes overnight to care for patients.

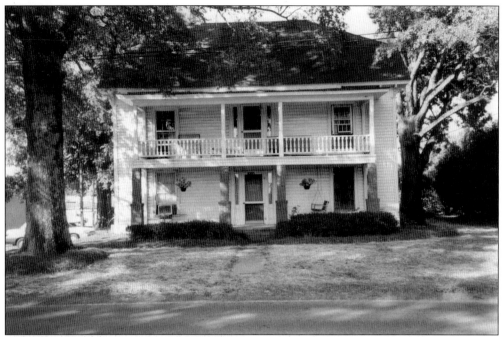

In 1887, Eli Henderson built this home on 60 acres of land, where he grew cotton and corn. He and his brother Dallas owned the adjacent Henderson Store. Students attending Bain Academy boarded at the home, which today is divided into rental apartments and owned by James McWhirter III and his wife, Judy.

William Frank Haigler and Nancy Elizabeth Wilson, native Mint Hillians, resided for many years on Bain School Road next to Philadelphia Presbyterian Church. They were the parents of Charles Bruce, Ruth (Belk), Edith (Ross), William Frank Jr., and James Boyce. William and Nancy are buried in the church cemetery.

It was an exciting time when electricity came to Mint Hill. Walter Junker, a self-taught electrician, installed the first electricity in most of the area homes and businesses. Son of George C.L. Junker, a German immigrant, Walter never married and lived with his sister, Mamie. He was an elder at Philadelphia Presbyterian Church and taught at the Ashcraft School, where he earned $30 per month.

T. Hassie Sustar was ready to take his sisters Dollie (left) and Myrtle for a ride in the car but probably couldn't reach the floor pedals. Hassie attended Cochrane Academy and Wingate College. He married Bleeka Lee and farmed their land on Idlewild Road as well as worked at the Southern Engineering Company in Charlotte. Their children are Billy, Norma, and Betty. Bleeka and her siblings lost their parents and grandmother when they were young and grew up at the Barium Springs Orphanage.

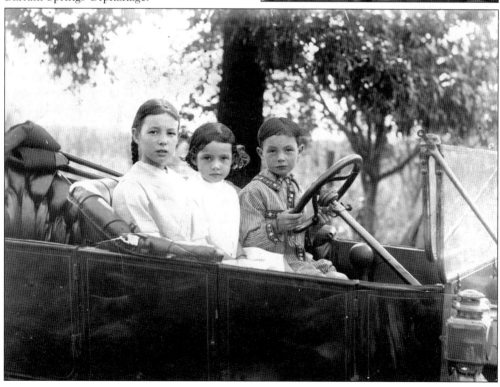

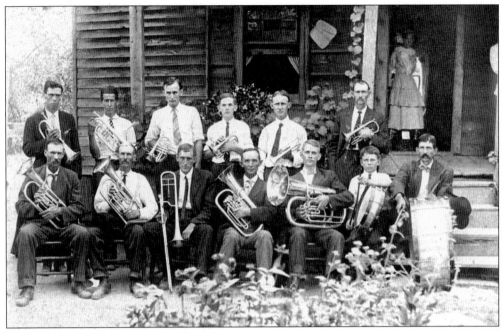

This picture was taken at William and Martha Jane Connell's house on Connell Road around 1917. Marshall Vance Flow is standing at the back left corner of the house. Though not identified, Ruben Connell and Jim Long are also in the picture.

Harris Jerome Black and his wife, Avery Nixon, raised corn, cotton, and sugar cane on their farm. Planted in the fall and harvested in the springtime, the cane was cut and stripped and taken to the mill behind their home to be made into syrup and molasses. Mr. Black also worked at the Mint Hill Pulpwood Company off Fairview Road. His job was to skin the bark off the pulpwood with a flat hoe blade.

Cpl. Earl Williams, son of Mr. and Mrs. Gaston Williams, was from the Clear Creek area near Arlington Church. During his tour of duty in World War II, Earl was taken prisoner and forced to walk 63 miles in what was known as the Bataan Death March. Upon returning home, he was the first veteran in the area to receive the special POW medal. Earl is a member of the Earp-Williams VFW Post in Mint Hill. He married Dorothy Bird.

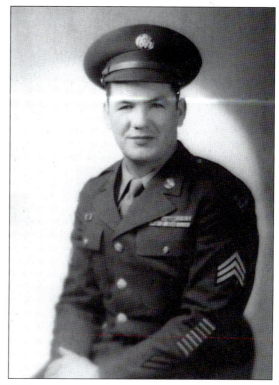

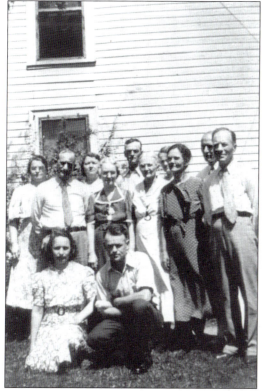

Dallas and Sarah Roscinder Henderson, along with Dallas's brother Eli, brought many services and businesses to Mint Hill—including a general store, post office, flourmill, and cotton gin. A telephone system was installed in their home with Sarah serving as operator. Dallas ran a Ford dealership in the building beside the home. In this photograph, Sarah is surrounded by her children and their spouses: Don and Mae Henderson, Max and Lola Long, Edith and Charlie Huitt, Bleaka and John Wilson, and Lillian and Dowd Henderson.

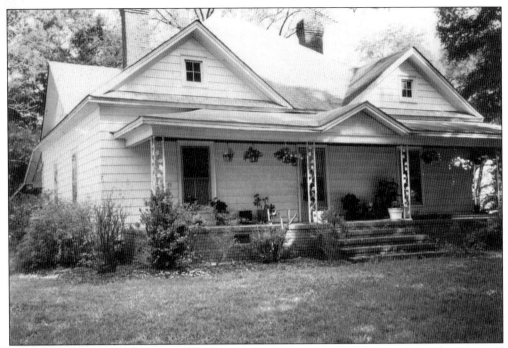

Arthur Lee built this house on Lawyers Road and lived here with his wife, Martha Ray, and their two daughters, Geraldine and Emily Lee. Later on, the McCall family occupied the home and farmed the land. Yates Phillips and his wife, Grace, now live here.

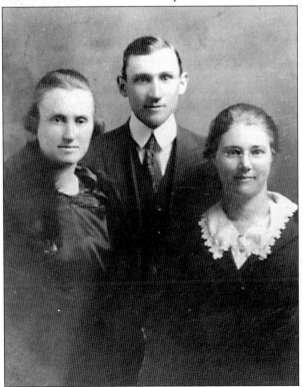

Walter Atlas Ferguson, the eldest of 11 children born to Nathaniel Jackson and Sarah Meismer Ferguson, was born on November 3, 1892, and grew up in Clear Creek Township. He married Margaret Jane "Maggie" Keenan, and they had 11 children. Walter bought his first camera in 1912, and with it strapped across the handlebars of his bicycle, he traveled the countryside taking pictures, pursuing his hobby of photography for more than 30 years. Pictured from left to right are Walter's sister Cora, Walter, and his wife Maggie Keenan.

When Milas W. Johnson Jr. retired from his job at the McEwen Furniture Company, he had plenty of time to do what he loved doing best—farming. His 30 acres of land on Truelight Church Road afforded plenty of land to grow fruits and vegetables for his family. Milas is one of ten children born to Milas Sr. and Margaret Montgomery Johnson. He and his wife, Hathen W., are the parents of Ralph Edward, Larry Eugene, Bruce Murray, Hugh Scott, Willie James, Curlee Moore, and Hathen Diane Johnson Wright.

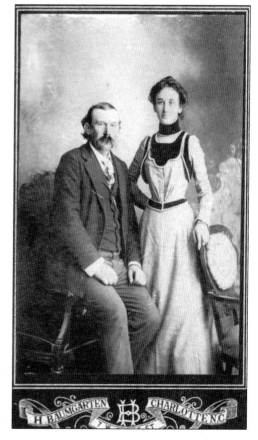

The marriage of Lela Beaver Morris and Zebulon Morris united two pioneer Mint Hill families. Zebulon was a great-great-grandson of John Foard, signer of the Mecklenburg Declaration of Independence, and a grandson of Revolutionary War colonel Zeb Morris. Zebulon first married Ada, and they had two children, Kate Mae and Watson. When Ada died, Zebulon married her sister Lela, and they had two children, Zebulon and Milton.

Johnny C. Wilson built this house on Bain School Road in 1890. Many families lived in it, but the last occupants were Robert and Beulah Quillen, both Bain School teachers and community leaders. Mr. Quillen also taught at Independence High School. Their son, Laurin, and daughter, Nancy Faires, sold the property to a developer, and the house was subsequently demolished.

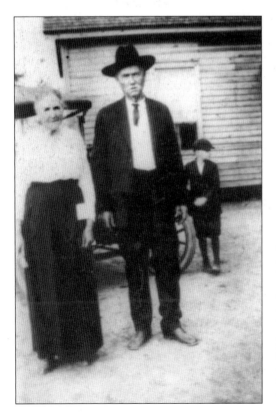

William Wallace Wilson (1853–1922) and his wife, Sarah Ellen Pinion Wilson (1861–1938), moved from Montgomery County in 1886 to farm and pan for gold in the Mint Hill area. Their mules Joe and Bill came from World War I Camp Greene near Charlotte and were used to pull their surrey. In 1913, William started a "wood yard" business that he ran for 20 years. Their children were John, George, William, Margaret, and Furnander.

Essie Jane Gregory Dorton, wife of Richard Lee Dorton, lived in the "old" downtown Mint Hill on Fairview Road at the turn of the 20th century with their children Betty (Whitesides), James Richard, Marjorie (Eudy), Ned, and Eunice (Keziah). The Keziah family ran the Stevens Mill off Lawyers Road.

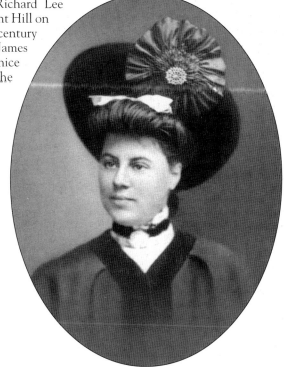

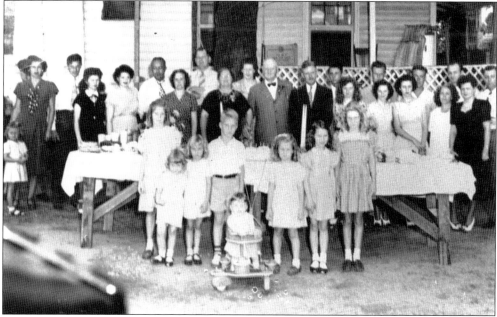

Friends and relatives join Dr. Ayer Manny Whitley and his wife, Esther Mangum Whitley, in a celebration under a large oak tree in the yard of their Mint Hill home. Friends recall Mrs. Whitley always calling her children by their full names: Mary Elizabeth, Clarinda Blair, Mattie Sethelle, Edna Earle, Esther Novella, Ayer Crouch, Johnson DiCosta, Daniel Phillip, George Wilson, Jessup Sholar, Walter Swindell, and Sam DeLee.

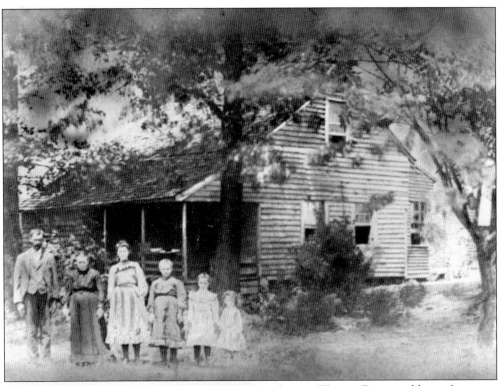

George Watson Davis and his wife, Benjamin Franklin Glenn Davis (known as "Kitty"), purchased this home in 1898. They are shown here around 1905 with daughters Annie Belle, Rachel "Blandy," Ola Inez, and Lula Estelle. Typhoid fever claimed the lives of two infant sons. They often talked about their mule-drilled well, which they considered a big improvement over the previous one that had been dug by hand.

Ira V. Ferguson (1894–1932) married Esther Flowe and built their home on land adjoining her father's farm. In 1921, Ira opened a small store in the Clear Creek area to meet the needs of that community. Ira became sick with lobar pneumonia, and with no antibiotic yet available, he quickly died from the vicious infection. Esther raised their small children, Edna Rebecca (Helms), Rayvon Vance Ferguson, Blanche Elizabeth (Grey), Aaron Flowe Ferguson, Eugene Lee Ferguson, Merl McDonald Ferguson, and Ned E. Ferguson.

Kate Mae Morris Duncan was 100 years old when this picture was taken in 1991. She attended Cochrane Academy near Matthews, Bain Academy in Mint Hill, and Linwood College in Gastonia before marrying J.V. Duncan and having three children. She was a descendant of John Foard, a Mecklenburg Declaration of Independence signer, and lived on part of his historic plantation. As the oldest female member of Philadelphia Presbyterian Church, she proudly carried the Julia Black Cane.

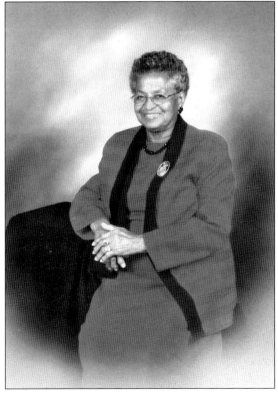

Elizabeth Black Miller was born in the Mint Hill area. Her parents are Avery Nixon Black and Harris Jerome Black. Elizabeth married Bruce Lawrence Miller in the 1940s, and they have four daughters: Monadell Miller Robinson, Mary Miller, June Miller, and Ruth Miller Hood, who is a former trustee of the Mint Hill Historical Society.

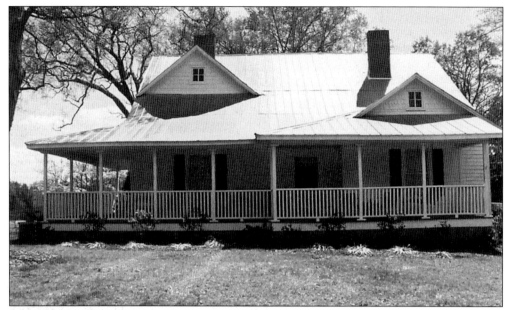

Banah Uriah Pigg and Carrie Phillips Pigg built this 10-room home in 1916 on their 100-acre farm on Cabarrus Road. B.U. was a highway supervisor when the first macadamized (rock) road was built in Mecklenburg County. He was also a gifted employee of Cole Manufacturing Company, where he designed many planter parts. The Henry Haigler family raised corn and cotton on the Pigg farm.

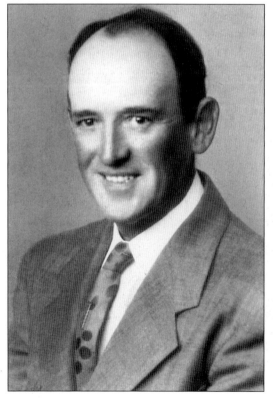

Zebulon B. Morris Jr., a sixth-generation farmer, operated a dairy on land that was part of the plantation owned by John Foard, his great-great-great-grandfather. Zebulon attended Davidson College before marrying Rena Mae Junker. They had three children: Herman, Lela, and Zeb. Lela died in an automobile accident in 1968. Zeb, a seventh-generation farmer, now raises Brangus cattle on Lebanon Road. Zeb also developed Morris Business Park. Herman's son Ted is a dentist who developed Morris Medical Park on another part of the plantation.

Marley Griffin and his brother Luther were owners of Pine Grove Dairy on Lawyers Road in Mint Hill. Before electricity came to the town, the brothers dammed the creek and built a water wheel–powered generator. Marley (left) is shown here in the processing barn with Jabo Coggins, an employee, and Marley's brother-in-law Dalton Purser sampling the chocolate milk before they begin the delivery route. On the counter are quarts of "sweet milk."

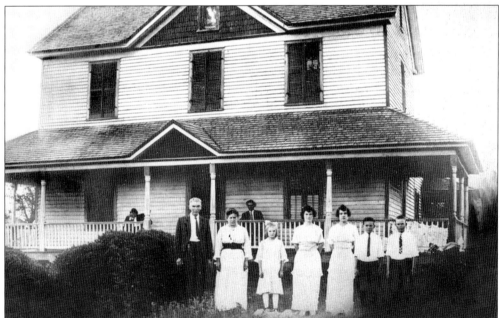

This house on Cabarrus Road was the original home of the Benjamin Estridge family. Pictured from left to right are Benjamin Estridge; his wife, Betty Moss Estridge; and their children, Gladys, Mamie, Grace, Dewey, and Clarence. Walter Phillips purchased the home and later sold it to McCamie Mullis. Kevin Mullis, grandson of McCamie, and Kevin's wife, Gina, now live in the home.

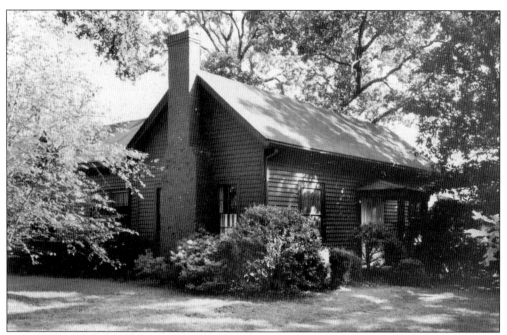

Sara and Tom Higgins lived in this old 1890s farmhouse, built by John Walker Wilson on Bain School Road. Sara often said it was hard to renovate a farmhouse with its treasures of hand-blown glass windows, old brick chimney, pine board walls, gabled roof, and front porch. Sara is a charter member of the Mint Hill Historical Society.

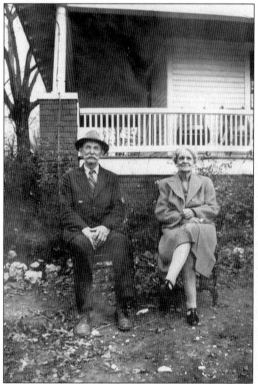

James Morrison Black (1874–1979) married Julia Campbell (1877–1970) in December of 1897. Their children are Dolph C. and William M. Black. Dolph contributed to tradition at Philadelphia Presbyterian Church when he gave his mother a walking cane that was crafted from a wild cherry tree in S. Pernay Ross's yard. Julia requested at her death that the cane be carried by the oldest female member of the congregation and that it be passed on as the Julia Black Cane.

Baron "Bus" King (left) was the son of Will King and Carrie King. As a mechanic at Jenks Ellington's Texaco Station at Lawyers and Matthews–Mint Hill Road, "Bus" would set a glass of water on the hood of a car and start the engine. No ripples in the water meant the motor was finely tuned. Baron's siblings are Leroy King and Mary Elizabeth Pierce.

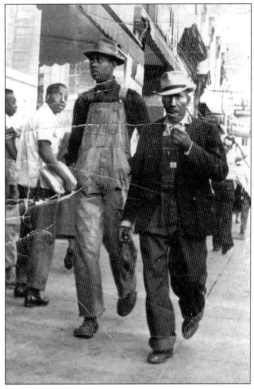

Luther Griffin, one of nine children born to James Alexander and Eugenia Huntley Griffin, married Leslie Mullis in 1930. Both of their fathers were teaching elders in the Truelight Church. The Griffins ran a dairy with Luther's brother, Marley, and wife, Mae. Luther and Mae also worked at Hudson Hosiery Mill. Luther later operated Griffin's Esso Station. Together, the Griffins grew a big garden, canned and preserved the bounty, and shared with neighbors and friends.

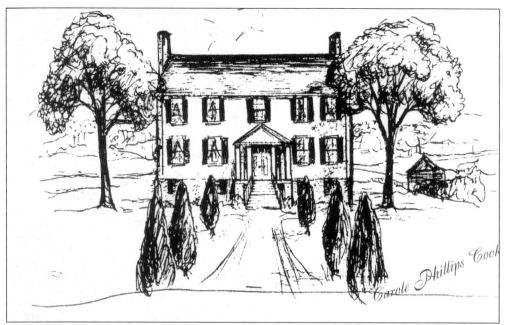

Enchanted with stories of Lou Brafford Phillips, great-great-granddaughter Carole Phillips Cooke drew this depiction of the house on the 1,650-acre track that Joseph Blair bought from William A. Harris in 1854. Local residents who remember the house say it was the most outstanding house in Clear Creek.

Children of Emma Houston Bartlett and George White Bartlett gather each July for a family reunion at Philadelphia Presbyterian Church. Curt Bartlett (back row, right) and many of his Mint Hill relatives worked for the Tennessee Valley Authority, a government-sponsored venture that built power plants.

Born in 1911, Fred Orr Brown proudly carries the John Bain Cane, presented to the oldest male member at Philadelphia Presbyterian Church. In an interview, he recalled attending a one-room school where some of his more elite classmates brought baloney sandwiches for lunch while he had to get along on old country ham biscuits and fried chicken. The community and church leader married Martha Duncan, and together they reared three children, Fred Orr Jr., Jean, and Timothy.

In 1937, Elizabeth Harris didn't have a high school to attend because most of the schools in her area were for white children. She wrote a letter to R.P. McCorkle, the principal at Clear Creek High School, requesting permission to further her education at the school. In 1940, Elizabeth received her diploma from Clear Creek, and at the 2000 class reunion, she was presented a certificate for "blazing trails" in education.

Clear Creek High School

Mecklenburg County North Carolina

This is to Certify That

Elizabeth Harris Black

has satisfactorily completed the regular course of study prescribed by the Board of Education for the High School and is granted this

Diploma

in witness whereof we set our hand and seal this first day of May, 1940.

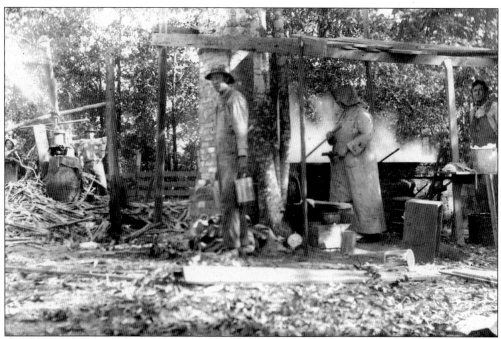

The Ferguson mules turned the press used to extract the juice from the cane to make syrup and molasses. The fire under the trough cooked the liquid down to syrup. The result of cooking the syrup longer was dark, delicious molasses. The Fergusons would soon be enjoying the fruits of their labor.

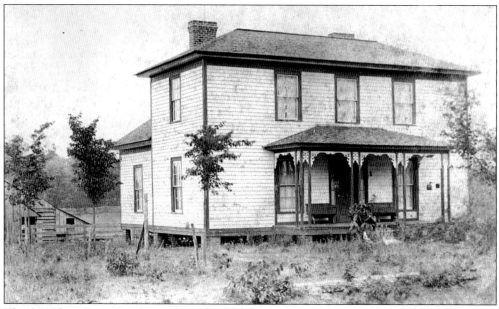

The Jonathan Lee Flow house on Albemarle Road near Lower Rocky River Road is still standing. Jonathan Lee Flow (1849–1928) was the son of Jonathan H. Flow (1813–1885) and grandson of Thomas Flow (1780–1845) of Mint Hill/Clear Creek. Jonathan Lee Flow married Addie Belk, and they had one daughter, Bessie Lee Flow, who married Francis Marion Redd, mayor of Charlotte in 1927. Lynn and Harry Rhodes now own the Flow house.

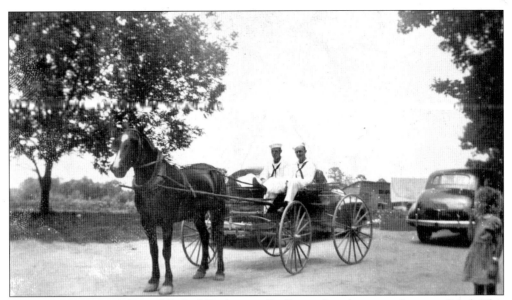

Dr. J.M. DeArmon delivered Buford DeArmon Griffin at their home on Lawyers Road. This picture of Buford and his navy buddy John Adams was snapped in 1945 while they were home on furlough. During the war, Buford's wife, Carmen Long, and their children, Melba and Jan, remained in Mint Hill. Their son, Alan, was born after the war. Buford bought his first used car when he married in 1939; the next year, he bought a new Chevy for $825.

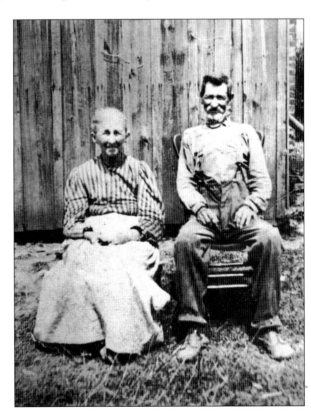

George "Mack" Wilson was the son of John Newton and Adeline Wallace Wilson. In 1866, Mack (1845–1907) married Mary M. Clontz (1850–1923). This picture was made in the late 1800s at their home on Brief Road, not far from the present Mint Hill Athletic Association Sports Complex. Their children are Minnie, Eli, "Mark," Mary, and Esther.

Silas McWhirter built this home off Fairview Road in 1880. Some of the log walls of the original four-room structure can still be seen today. The farm once included a sawmill, a cotton gin run by a steam engine, and a brick-making facility. Originally a land grant from the king of England, the property is currently owned by descendant Bill McWhirter Sr. and his wife, Johnnie.

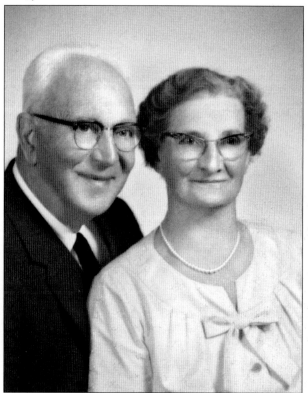

Henry Baxter and Maude Allen Forbis were active members of Philadelphia Presbyterian Church. Baxter farmed and worked at Cole Manufacturing Company in Charlotte, while Maude cared for their six children: H.B. Jr., Wilma (Todd), Margaret (Duncan), Frances (Epley), Betty (Ross), and Dick. All went to Bain High School, married local people, and made their homes in the Mint Hill area.

In 1903, Wharey Junker was appointed to deliver rural mail—an experimental service deemed too costly and sure to fail. Driving a buggy pulled by his horse Doll, Wharey picked up the mail at the Allen train station and delivered it to wooden boxes at 65 homes on his route. He began delivering mail by automobile in 1916. By the time he retired in 1934, his route was 35 miles long with 300 stops.

Sadie Russell and her brothers lived in the Arlington community and attended Clear Creek High School. She married Milton Black, a concrete contractor and the brother of Elizabeth Black Miller. Sadie and Milton, who had two daughters, later made their home in Virginia.

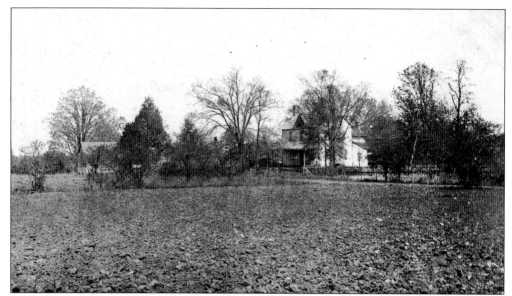

A descendant of John Foard, Milton Morris ran a dairy and farmed the land that was a part of the original 1,500-acre plantation. He still lives at the lovely two-story home place on what is now Margaret Wallace Road. Milton married Ruth Wilson, and they had one son named David. David married Frances Willis, and they had two daughters, Janie and Sarah. Janie married Keith Austin, and Sarah married Eleuterio Jimenez.

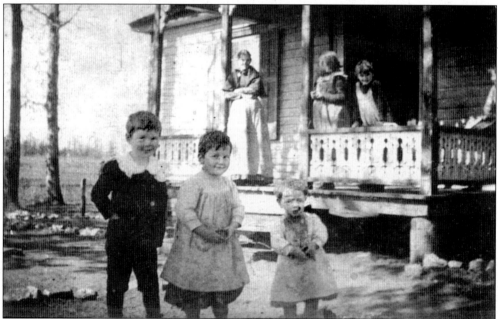

Marcena Hinson Lemmond, wife of James Evan Lemmond, stands on the porch of her home on the Fayetteville Road (now Albemarle Road). Daughters Essie (left) and Sadie stand with her on the porch, while sons (from left to right) Joe, Dexter, and Jennings stand in the yard. Mrs. Lemmond was the daughter of Eli Hinson of the Old Brick Plantation in the Arlington community. Joe married Elberta Smith; Dexter married Minnie Lowrance; Jennings married Agnes Wetmore; Essie married George Brown; and Sadie married Furman Wall.

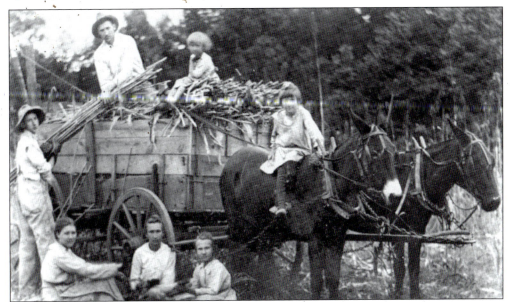

It was cane-cutting time on the Walter Atlas Ferguson farm when this picture was made. Standing on top of the wagon is Walter. His wife, Margaret Keenan Ferguson, is the woman on the left sitting on the ground. The others are unidentified brothers and sisters of Walter.

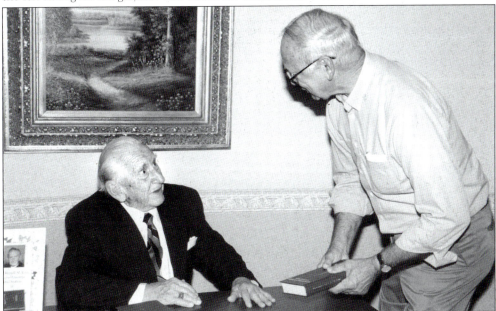

After 30 years, Russell Martin Kerr retired as pastor of Philadelphia Presbyterian Church. Elder Ray Waltman expressed the congregation's feelings: "Rev. Kerr and Nancy brought a little heaven on earth to Mint Hill with this extremely fruitful pastorate. They taught a lot of us how to worship, witness, love, care, fellowship, live as a family, live as a community and in general how to appreciate each other." A volunteer fireman, Kerr encouraged the formation of a Boy Scout troop and helped create the MHHS and the Piedmont Area Development Association (PADA), a community development program. After retiring, he wrote *The Presbyterian Gathering on Clear Creek*, a history of Philadelphia Presbyterian Church. Here he signs a book for Lewis West.

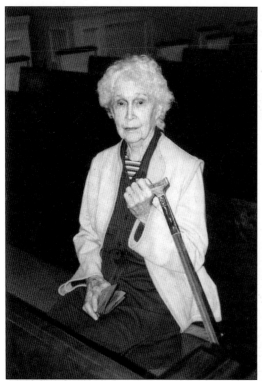

As the oldest living female at Philadelphia Presbyterian Church, Lula Nelson (born February 22, 1903) is the eighth holder of the Julia Black Cane, which she has carried since 1998. She currently resides with her grandson Joe Hough and has always enjoyed reading, sewing, baking, and playing the accordion. She and her husband, Homer Lee Nelson, moved to Mint Hill in 1947. Mary Jo Jarrell, their only child, is the mother of Joe Hough.

A. Smith Wilson built this beautiful home on Matthews–Mint Hill Road around 1908. The lumber came from timbers that were cut and milled on his 400-acre farm, where he grew cotton and fruits and raised dairy cows. The Wilsons had 11 children: Daisy Lou Titia Wilson Christenbury (1884–1932), Nancy Eliza (1885–1888), Cyrus Johnston (1888–1945), Maggie Emma (1890–1910), Thomas Walter (1893–1970), Mamie Irene (1895–1974), unidentified infant twins (1898), Baxter Arthur (1900), Martha Clarinda (1902–1993), and Carl Smith (1906–1921).

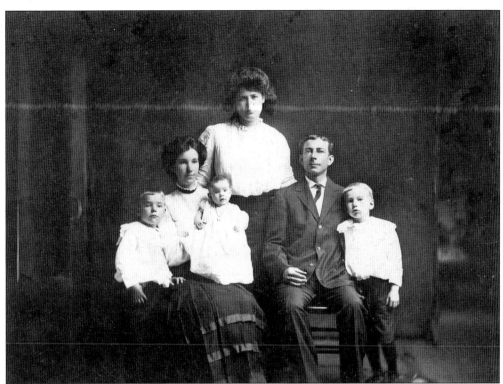

Wharey Junker married Rena McLean in 1900, and they reared four children in their beautiful home on Albemarle Road. Pictured are Eugene Wellington, who married Mae Blackwelder; mother Rena McLean Junker; Rena Mae, who married Zebulon B. Morris; father Wharey Junker; and Harrell McDonald, who married Elizabeth Caldwell. Ted, who was not yet born, married Jessie Flowers. The unidentified lady standing behind them helped care for the children.

Carl and Olin Wilson were the children of Leila Roberta Biggers Wilson and William Allison Wilson, who made their home on Lawyers Road in Mint Hill. Carl married Louise Hoover in 1939, and Olin married Helen Ashcraft in 1934.

Nathan Marcus Phillips, son of Josiah Leroy Phillips and Margaret Wilson Phillips, was born on September 29, 1847. A "boy soldier," he served in the 7th Regiment Infantry, Company H, in the Civil War. Following the war, he married Alice Crawford Blair, born to Joseph and Tharza Hilton Blair, on January 30, 1854. Their home was located on Blair Road near the I-485 interchange.

During the 1940s, Sam Robinson lived on the Black farm, the site of the present-day Mint Hill Park on Fairview. When Bill Black opened his service station and grocery store across the street, Sam worked for Bill and lived in the garage apartment behind Bill's home.

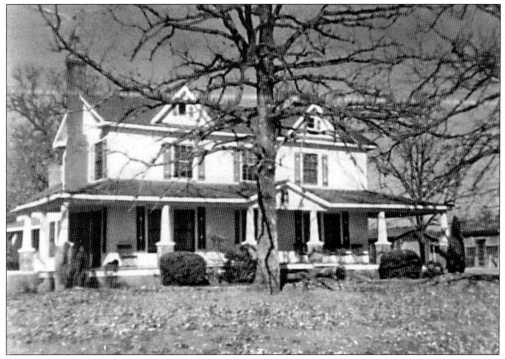

The Henry Baxter and Maude Allen Forbis home on Matthews–Mint Hill Road is a designated Mecklenburg Historic Landmarks property. Built by Richard C. Forbis (1837–1926), the house features handmade bricks in the foundation and chimney and pegged timbers in the framing. It is one of the county's few remaining buildings constructed in this manner.

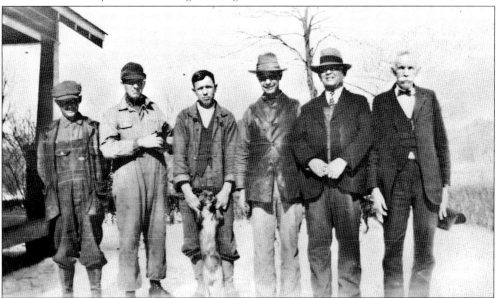

Elam, Lem, Gaston, Phillip, and Baxter Williams are shown from left to right with their father, E.H. Williams, at the far right in this 1930s photo. E.H. and his sons were all farmers except for Lem, who made the military his life career. The family home place was located on Williams Road behind Arlington Baptist Church.

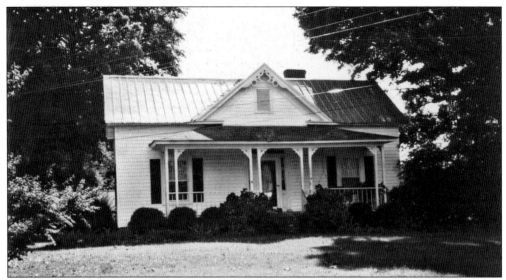

Built around 1895 and known as the Frank Hargett home, the house is located behind Bain School on the old Mint Hill postal route. The wraparound porch is now gone. The Ranson Crowell family lived in the home for a while before the S.C. "Sandy" Ross family. Sandy's son Hal G. Ross is the present owner.

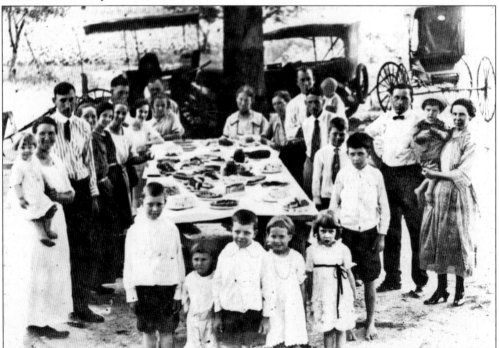

The Keenans arrived at the family reunion in 1922 by automobiles and horse and buggy. The young children in front of the table are, from left to right, Pete Todd, Earl Ferguson, Wilbur Todd, Marian Keenan (Whitley), and Cattie McGinn. To the left of the table are Maggie Ferguson, holding Elaina, and Walter Ferguson. Others pictured are Mack Keenan, Grandpa Keenan, Grandma Keenan, Flora Todd, Connie Todd, Clyde Todd, ? McGinn, Ed McGinn, and Eunice McGinn.

This photo of Bill Tilley with his mother, Selma Duncan, was taken about 1950 at their Blair Road home (the Nathan and Alice Blair Phillips home place). The family Ford is in the yard. Bill Tilley married Sue Todd, and they reside in Mint Hill.

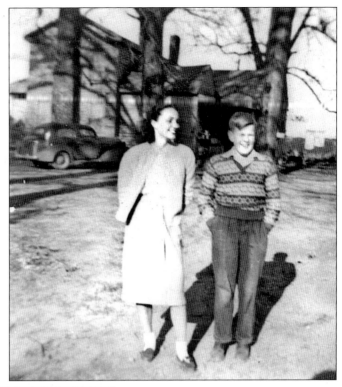

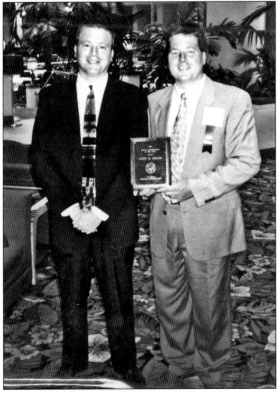

Scott Griffin, president and founder of Griffin Masonry, Inc., is shown here with brother and business partner Tony Griffin upon receiving the Small Business Association's 1998 North Carolina Young Entrepreneur of the Year Award in Greensboro. Recipients of the award are under age 30 and show substantial business growth and product innovation.

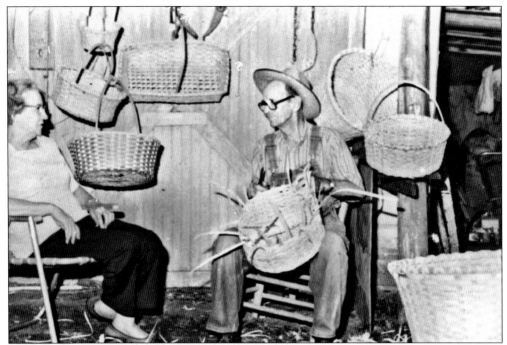

Dexter Connell, who grew up in the Clear Creek Township on Connell Road, was known for his handmade baskets and tall corn. This photo of him with his wife, Callie, was taken when they lived on Albemarle Road across from Clear Creek School.

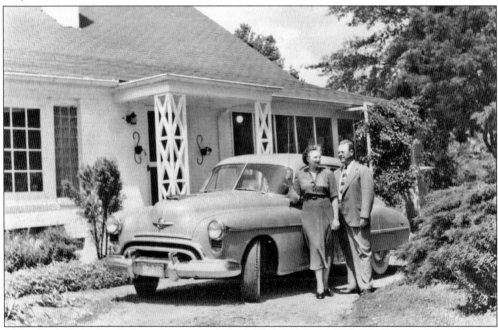

Watson Morris married Lola Hood, and they adopted a daughter named Mary Ann. Lola named their road for the "Cedars of Lebanon," and the beautiful cedars that they planted around their Lebanon Road home still thrive today. Watson owned and operated Lebanon Dairy Farm, and a large barn from that era survives.

Sandy C. Ross and his wife Mary Hallie Helms Ross had 12 children: Phines, Javie Helms, Pernay Ross, Eula Baucom, Pauline Black, Cassie Simpson, Hugh Ross, Joe Ross, Rachel Sykes, Flora Ross, Baxter Ross, and Mae Hood. Mary died at an early age, and Sandy later married Rosiland Getty, pictured here. Together, they had 12 children: Conley Ross, Dwight Ross, Helen Ross, Ralph Ross, Eloise Black, Vivian Ross, Ann Maxwell, Jean Greene, Betsy Bledsoe, Sue Howell, Hal Ross, and Lanny Ross.

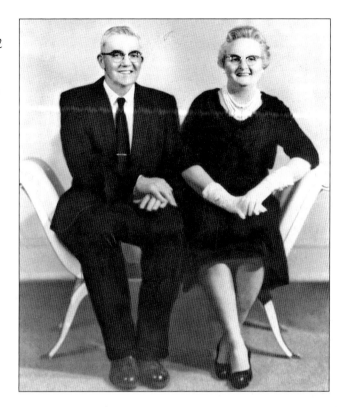

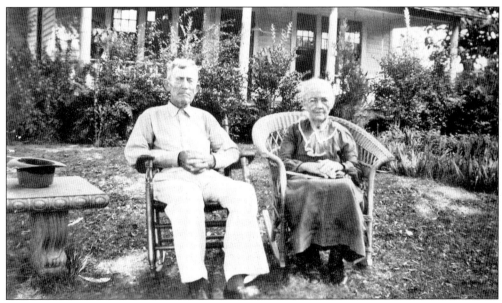

James Franklin and Mary Tirzah Biggers Phillips married in 1881 and lived on a 90-acre farm on Lawyers Road in Mint Hill. They were the parents of Walter, Clifford, Ernest, Mamie (Beaver), Jennie (McWhirter), and Brown Phillips. When Mr. Phillips became the oldest male member of Philadelphia Presbyterian Church, he was presented the John Bain Cane.

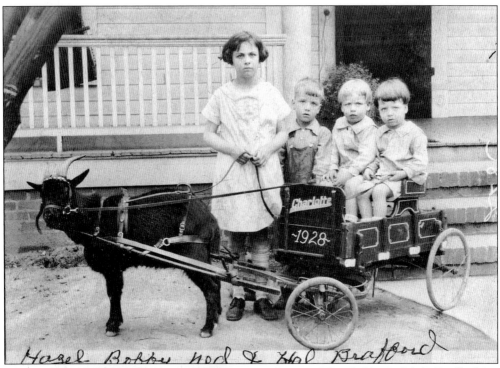

Hazel Bobby Ned & Hal Brafford

The children of A.B. Brafford and Bessie Mae Flow Brafford often went for a Sunday ride in their 1928 goat cart. In this picture, twins Ned and Hal sit in the small cart as their older brother Bobby and sister Hazel wait their turn to ride.

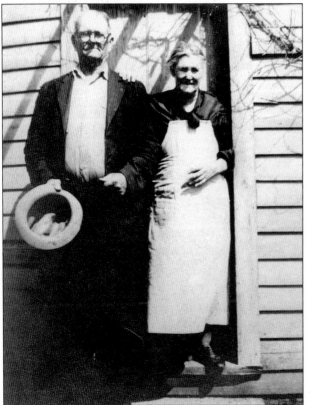

John N. Wilson (born 1856) and his wife, Deala Pinion Wilson, lived in the old Surface Hill assay office after it was converted to a dwelling. Their son William Larsie Wilson (1892–1966) built his home next door and lived there with his wife, Minnie Belle Griffith, and their children: Odessa Marie, Lela Mae, Agnes Colia, Dewey DeWitt, John William, Marvin Ebenezer, Pressley Leroy, Annie Jane, and Walter Berdette.

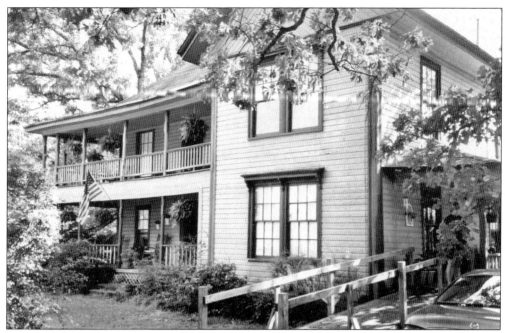

In 1886, John Calvin Wilson and his mother built this home on a 298-acre farm on Bain School Road. With the help of five tenant farmers, Wilson farmed corn and cotton and hauled it by mule to Matthews. Ernest and Irene Phillips bought the house and a few outbuildings. Nita Phillips, their granddaughter, now owns the home, designated "historic" by the Charlotte-Mecklenburg Historic Landmarks Commission.

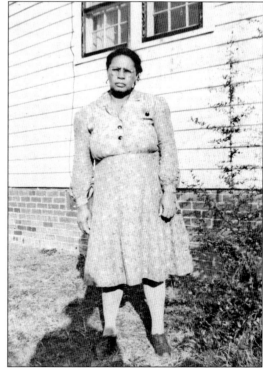

Katie Robinson (Morris) was born in Union County to George and Frances King. She married John Robinson and they had nine children: Durante Robinson, Lura Robinson (Ervin), Georgia Robinson (Firms), Sarah Frances Robinson, Obery "Pete" Robinson, William A. "Bub" Robinson, Dorothy Robinson (King), John D. "Jay" Robinson Jr., and Betty S. Robinson. In 1955, John Sr. died and Katie married Lewis Morris. The Morrises lived and worked on James Black's farm for over 60 years and were members of Red Branch Baptist Church. Katie also helped James's wife, Julia, and the family with their laundry and other household chores.

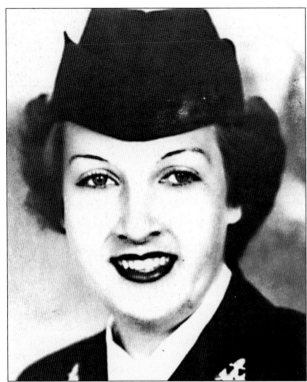

Annie Euilla Tompkins Guillen (1928–2003) was born to Carey Franklin Tompkins and Beulah Wilson Tompkins in the Allen community near Albemarle and Cabarrus Roads. Annie, shown here in her navy uniform, served her country during the Korean War, where she met her Mexican-born husband, Ramon Cruz Guillen (1924–2002).

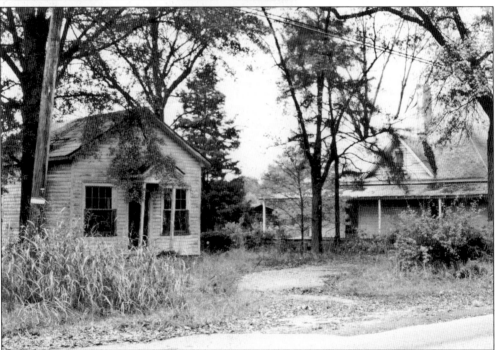

The office of Dr. Ayer Whitley was just a few steps out the front door of his large home on Fairview Road. Originally a big one-room structure, it was later divided into private examination rooms and a front office. This picture was taken just prior to the building's restoration.

Built around 1900, the Louie Lee home originally stood on Matthews–Mint Hill Road near the McEwen Funeral Home. In 2003, the Mint Hill Historical Society presented Catherine Curlee with the first Preservation Award for her efforts to save this wonderful home, which she relocated to Hoodridge Road. Pictured here in 1931 are Helen Hall Lee (wife of Louis Wilson Lee), John Newton Lee and his wife, Kathryn Wilson Lee, and Myrtle Rae Lee (wife of John Arthur Lee).

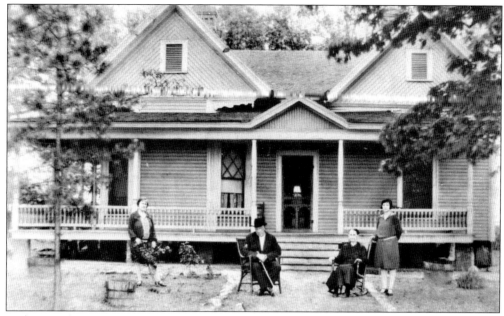

Nathan, John, and Samuel were the sons of Margaret Wilson and Josiah Leroy Phillips of the Pioneer Mill community, also known as the Rocky River Presbyterian Settlement. Nathan married Alice Crawford Blair, the daughter of Tharza Hilton and Joseph Blair. The Joseph Blair plantation home on the Concord Highway, also known as Blair Road, was destroyed by fire in the early 20th century. Many of the descendents of Joe and Tharza still live in the Mint Hill area.

Born in Mint Hill, James Hampton Black is a graduate of Bain High School and Davidson College. He served his country during World War II and married Beulah "Boots" Howell. Their two are James Jr. and Nancy Black Norelli. In addition to his family and professional life as an accountant and real estate broker, he has served his community as a member of the Selective Service Board; Master of the Masonic Lodge; Democratic Party Precinct Chair and State Executive Committee; Philadelphia Church deacon, elder, and treasurer; charter member of MHHS; VFW Post 4059 local, district, and state commander and National Council member.

William Lorenzo Hood (1870–1933) built this home on Dan Hood Road in 1906. William married Zelda Brown in 1893, and together they had two children, Lola Rivers Hood (born 1895) and Mary Belle Hood (born 1897). A farmer and at one time the mayor of Matthews, Lorenzo was also a liveryman whose business was renting horses, mules, buggies, and wagons. Horses were kept watered, fed, harnessed, and ready for riding.

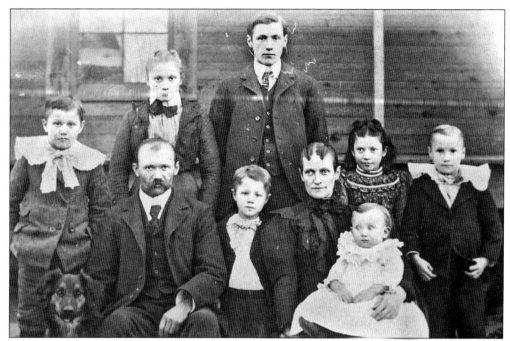

The William Harrison and Jane Marie Wilson Hood family portrait was taken in 1902 at the family home. William and Jane are shown with their son Luther, who married Lilly Mae Allen, and baby Arthur, who married Ethel McEwen. Standing from left to right are Johnson, who married Grace Robinson; Maggie, who married Earle Stinson; Lester, who married Clara Wilson; and twins Hester (who married Reece Moser) and Chester "Check" (who married Eva Lee Baird). Check and Eva Lee had three boys, William Chester Jr. and twins Harry and Larry.

Edward Alexander McWhirter, son of Silas Alexander McWhirter, was born and reared in Mecklenburg County. Ed served in the army as a corporal in the 52nd Company, 5th Group MTD, during World War I and was stationed at Camp Hancock in Georgia. He married Ethel Neese, and they had eight children. He died in 1965 at the age of 73.

James Conner Flowe (1890–1981) and Verda Emma Brafford (1888–1980) grew up in the Clear Creek community. James, son of Junius and Mary Etta Seehorn, and Verda, daughter of Jesse R. and Henrietta Robinson Brafford, were married January 17, 1909, at the Philadelphia Church manse. Prior to going to Arlington School, Verda attended a small school called Taylor's Turnout, while James went to the old Houston School that eventually became their home. Their children are Mary Wilma McEwen, Hilda James Campbell, Ruby Mae Skidmore, Herbert Lee, Paul Yates, Jessie Edith Griffin, Judy Eloise Marks, and Jack Edward.

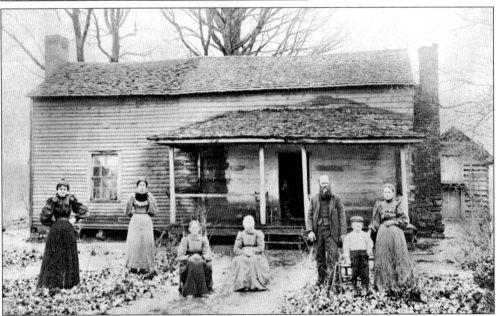

John Nisbet Rodgers is pictured with his wife, Eliza Flow Rodgers, and their small son, Bonar Day Rodgers, at their home on Albemarle Road near Dulin's Grove Church. The ladies in the picture are not identified, but the two younger women are believed to be John and Eliza's older children. The two older women may be their grandmothers.

All 12 of the Houston children gathered around their father, William Thomas Houston Sr. (1856–1948). Their mother, Martha Matilda Dulin is not shown in this 1940s picture. From left to right are children John M., Benjamin A., Martha Ann (Stilwell), Henry J., Carey Myrtle (Allen), Ethel Jane (Mullis), Timothy S., George C., Daniel J., William T. Jr., Emma (Bartlett), and James Luther.

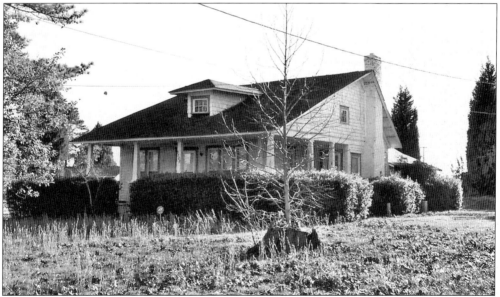

David Guy Dulin, a fourth-generation descendant of Sugar Dulin, and his wife, Margaret Jane Dulin, purchased this home at Dulin's Crossroads in 1919. Their 11 children are Mary Emma, Charles Milton, Harvey Thomas, Annie Brown, Rosella, Bertha Jane, Davie Lee, Katherine Louise, Margarette Calvin, and Martha Elizabeth. It was said that the area around Philadelphia Church was so heavily populated with Dulins it was called Dulin Town.

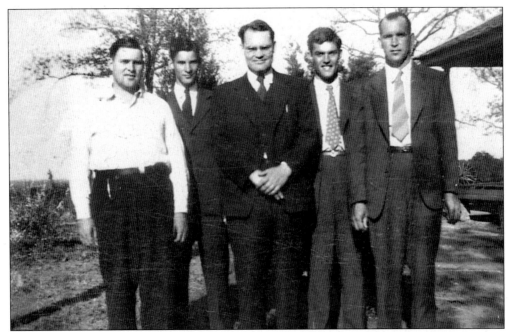

Five of the seven sons of Calvin Wilson Mullis and Ethel Houston Mullis are shown from left to right: Olen (1909–2000), Herbert (1930–1947), Stacy (born 1923), Dewitt (1914–1985), and Bruce (1911–1995). Stacy and Brice worked for Harrison Wright Electrical Company. Other children of Calvin and Ethel are Luther (1918–1922), Jennings (1917–1937), Mattie Lee (born 1913), and Mary (1920–2002.)

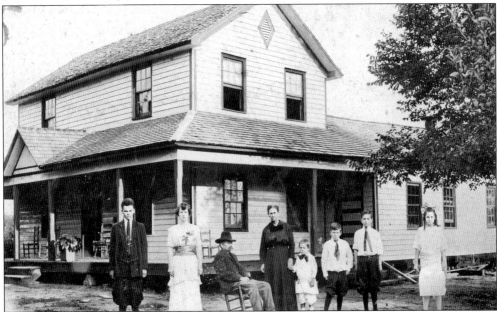

The J.R. Brafford home place was located on a road now known as Williams Road. J.R. married Sarah "Sallie" Dunlap in 1876. After her death, he married Henrietta Robinson. The father of 15 children, J.R farmed and ran a cotton gin and a wheat and corn mill. Shown in the picture, from left to right, are A.B., Della, J.R., Henrietta, Ezell, Bland, Zeb, and Zona Brafford.

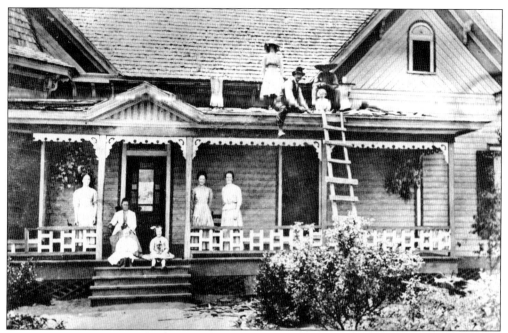

In this 1901 photo at the home of Thomas and Mary E. Miller Mann, mother Mary is sitting on the porch with her daughters (from left to right) Martha, Jeanette, Grace, Mamie, and Blanch. On the roof (from left to right) are Minnie (daughter), Thomas, and his brother, Lonnie, who are keeping a watchful eye on daughter Carrie while making roof repairs. Built by Thomas Flow, the home was destroyed by fire in the 1970s.

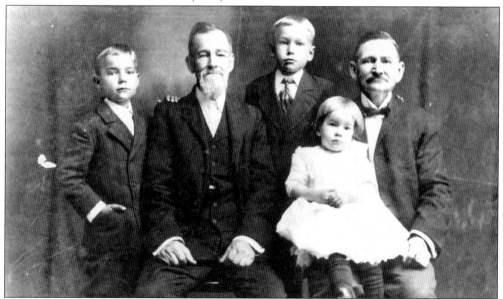

This family portrait includes the three grandchildren of Hugh McLean (left) and George Carl Lewis Junker (right). McLean's daughter Rena married Junker's son Wharey. Both families lived on the Fayetteville Road, now Albemarle Road, and were active members of Philadelphia Presbyterian Church. The children, from left to right, were Eugene, Donald, and Rena Mae Junker. George was instrumental in starting Robinson Presbyterian Church.

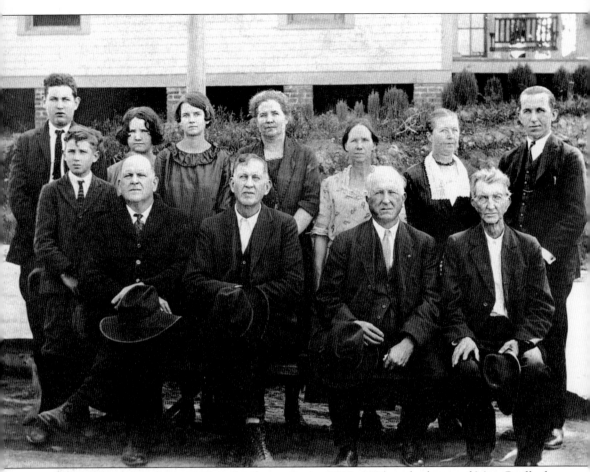

This picture was taken at a Flow family reunion c. 1923–1924 at the home of Matt Brafford Ellington in Concord. Shown from left to right are (seated) William Sherman Flow, Jacob Wilson Flow, John Howard Cosby Flow, and David Clark Flow; (standing) Jacob Wilson Flowe Jr., Theodore Roosevelt Flowe, Winnie Ruth Flowe, Annie Mae Flow, Willa Mae Flow, Ada Haigler Flow, Margaret Morgan Flow, and William Troy Flowe.

Two
BUSINESS AND COMMUNITY

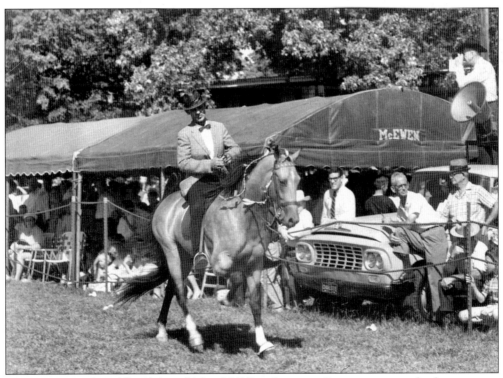

The Goose Creek Saddle Club and Mint Hill Development Committee were the first sponsors of the community Horse Show, with top participants receiving trophies and ribbons. In 1965, the newspaper reported that the event at Bain School attracted a surprisingly large crowd of 5,000 people. In later years, the Mint Hill Jaycees sponsored the shows. In this picture, Dolph Black demonstrates his fine horsemanship.

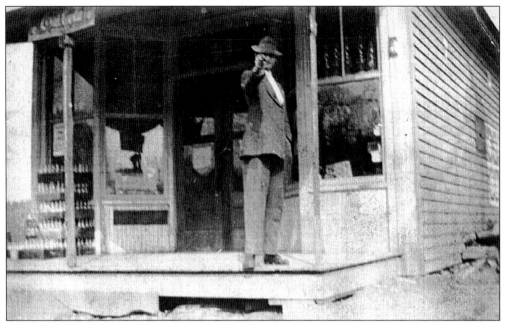

Around 1908, the R.J. McEwen & Son General Store opened at the corner of Lawyers and Matthews–Mint Hill Road, selling feed, fertilizer, seed, farm supplies, gas, handmade coffins, clothing, shoes, and general merchandise and hardware. Over the years, the store changed to meet the needs of the community.

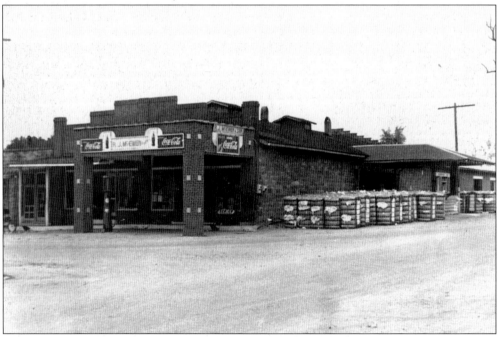

R. Johnson McEwen bought and sold cotton at his store, serving the needs of the small rural community of Mint Hill. This remodeled building with additions, shown here, was divided into smaller units and included a men's clothing shop, a grocery and meat store, an electric appliance center, gas pumps, and a funeral home.

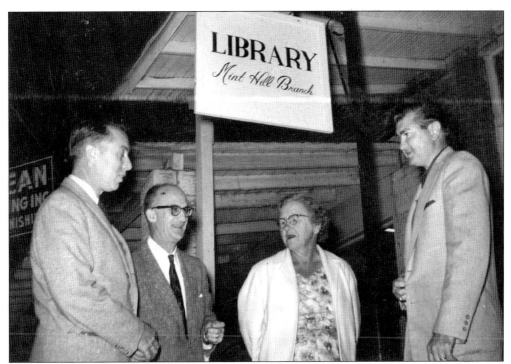

Originally a volunteer service for the community, the first library was located in a small space in the McEwen Shopping Center but later occupied several locations before moving to its present building in 1999. Shown here from left to right at the first library are William Yandell, Bain School principal L.J. Lowen, Ethel Flowe Ferguson, and Howard Ford.

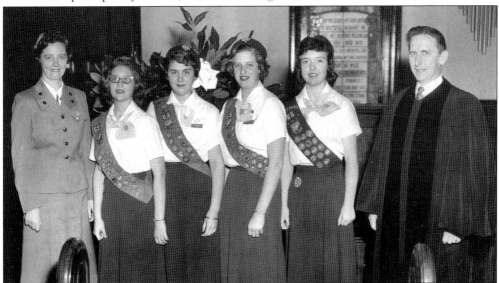

During the 1950s, Girl Scout leaders Ann Davis, Helen Anderson, and Luda Morgan assisted local girls in their efforts to earn the Curved Bar, the highest award possible. A representative from the Hornets' Nest Girl Scout Council (far left) presented this prestigious award to (from left to right) Sue Lemmond, Florence Girard, Carolyn Morgan, and Gladys Phillips. The Reverend Russell Kerr, pastor of Philadelphia Presbyterian Church, offered his congratulations.

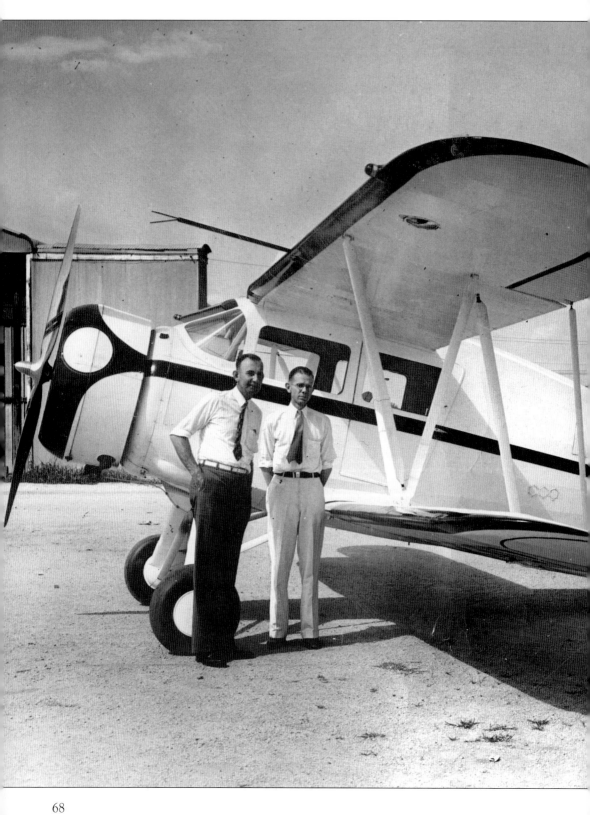

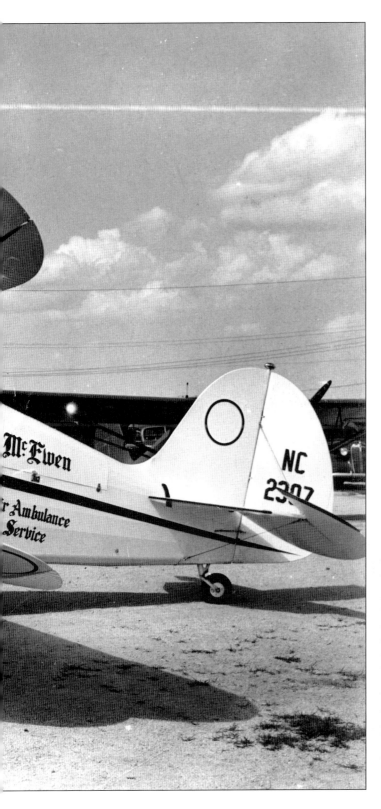

Very few communities in the United States enjoyed air ambulance plane service, and there were none in the Southeast except the one offered by McEwen Funeral Service. In this picture, visionary Carl McEwen (left) and George Canipe, a funeral home employee, are shown with the single engine biplane that saved many lives in the 1930s. At the request of the federal government, McEwen donated the plane to the war effort.

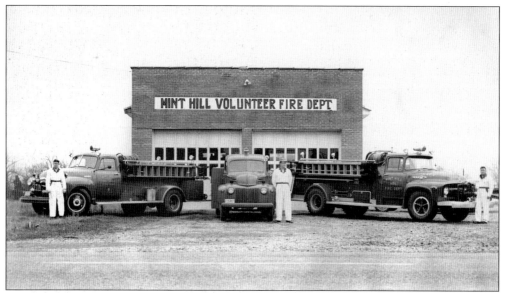

Tragic fires during the 1940s and 1950s prompted the chartering of Mint Hill's first fire department in 1952, located on Matthews–Mint Hill Road on land donated by Carl J. McEwen (today the site of the Honda repair shop). Volunteer firemen signed bank notes to buy the first fire truck and subsequent others for the community. Today the fire department is operating in a modern fire department facility on Fairview Road. Firemen shown in this 1957 photo are, from left to right, Jack Wallace, Ken Baucom, and Walter Earp.

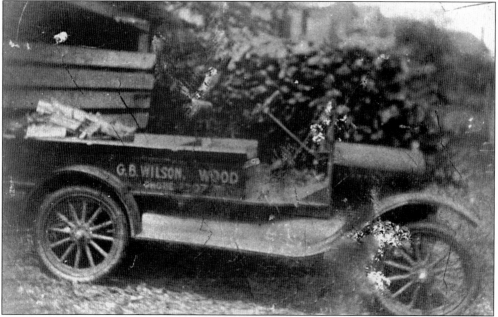

George Benjamin Wilson (1881–1924), son of William Wallace Wood and Sarah Ellen Pinion, ran Wilson's Coal and Wood Yard. The owner purchased wood by the trainload, cut and split it, and then sold it to local folks, many of whom used wood stoves for heating and cooking. George and his wife, Caroline Hudson, lived in the Wilson Grove area with their four sons, Rufus Mack, John William, George Thomas, and Carl Reid.

It was a slow day at the Texaco Service Station on the corner of Lawyers Road and Matthews–Mint Hill Road when this picture was taken. Shown are Jenks Ellington (left) who owned and operated the business, and Cooler Moore, who pumped gas, serviced cars, changed tires, and had a way of making his customers glad they had stopped by to see him.

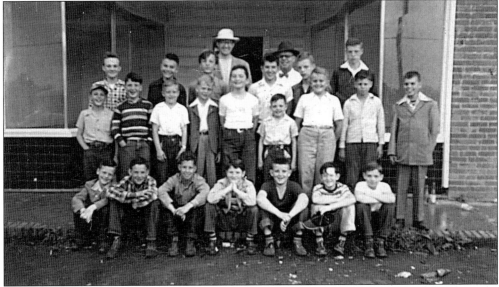

The purpose of the Boys of Woodcraft youth program, formed around 1950, was to train young Americans to be the leaders of tomorrow. Shown from left to right are (first row) Jerry Mullis, Donnie Presson, Richard Mullis, Melvin Ross, Bud Dulin, Sidney Cook, and Larry Black; (second row) Doug Hough, Olin "Tweedy" Flowe, Johnny Earp, Frankie Dulin, Laurin Quillen, Jack Earp, Eddie Rushing, Johnny Mullis, and Robert Smith; (third row) Bobby Kiser, Mickey Ellington, G.V. Baucom, Eddie Price, Frank Earp, and Bobby Earp; (fourth row) leaders George Cook and Grady Donaldson.

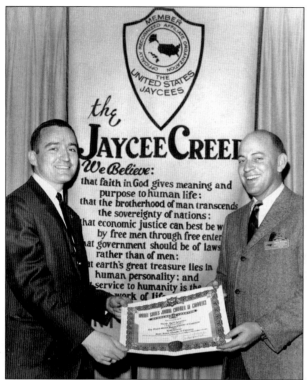

Laurin Quillen was installed as the first president of the Mint Hill Jaycees in early 1966, when 44 charter members signed the oath of office. Other officers were Bill Furr, Eddie Price, John Black, Olin Flowe, Eugene Crockett, Jack Earp, and Larry Black.

In 1957, the Piedmont Area Development Association (PADA) was created in Charlotte to promote community development. Local communities accepted the challenge to make improvements for pride and a cash prize. Beautification projects such as painting or replacing old mailboxes made Mint Hill the winner. Car horns honked as town officials paraded through town with their victory prizes. Clear Creek and Mint Hill continued to earn prizes each year until the program was discontinued in the 1970s.

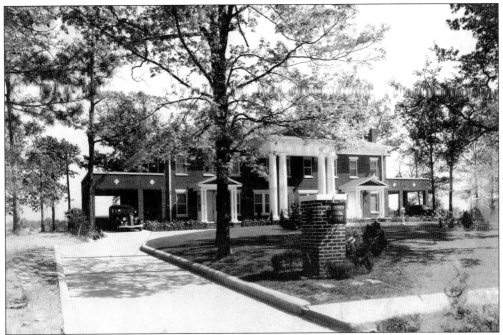

Carl J. McEwen constructed the stately McEwen Funeral Home on Matthews–Mint Hill Road in 1935. People drove from miles around to see the beautiful brick building being constructed. Later offices were opened in Charlotte, Derita, Monroe, and Pineville.

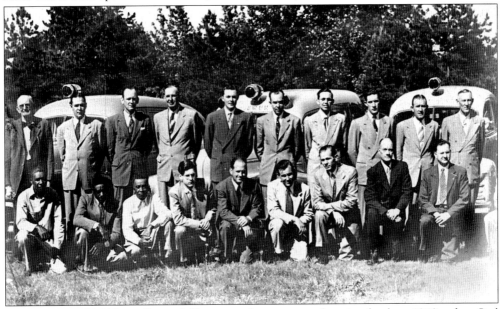

This picture of McEwen Funeral Home employees was taken in the late 1940s after Carl McEwen expanded his funeral business to Charlotte and Monroe. Pictured from left to right are (front row) unidentified, Ike Dunn, Ernie Reid, unidentified, W.T. Wall, Tom Lee, George Canipe, unidentified, and Lawrence Nesbit; (back row) R.J. McEwen, Charles Hunter, George Davis, Carl Johnson McEwen, Martin Holland, Lee Gulledge, Lester Anderson, Brice Hunter, Jack McEwen, and ? McLaughlin.

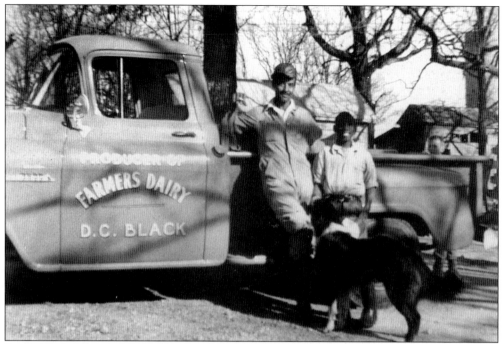

Sam Morris and stepson Alex lived and worked at the Dolph Black Dairy during the 1950s and 1960s. Black established the 250-acre dairy in the 1940s and sold milk from his herd of 150 cows to Farmers Dairy in Charlotte until 1965. Dolph and his wife, Mary, along with sons Larry and Tommy, were involved in the farm and community life.

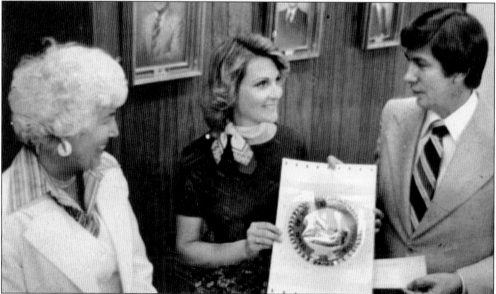

Commissioner Audrey Mayhew (left) and Mayor Troy Pollard (right) congratulate Sue Lemmond Helms for her winning design of the Mint Hill Town Seal. The seal features mint leaves encircling sketches of Bain Academy and Philadelphia Presbyterian Church, reflecting the community's rich history. In 1984, a bronze-cast town seal was imbedded in the concrete sidewalk of the breezeway at the town hall.

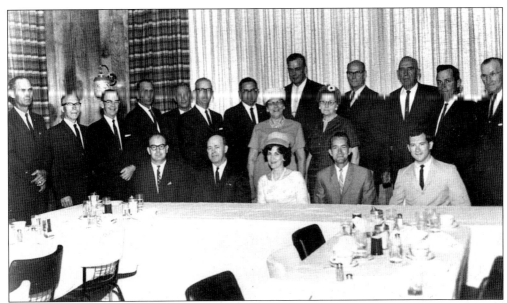

In the early 1960s, a group of citizens invited American Bank and Trust Company of Monroe to open a branch on Matthews–Mint Hill Road. A big grand opening celebration, complete with ribbon-cutting ceremony, welcomed the much-needed service to the community. Shown from left to right are (seated) Sam Sain, John McEwen, unidentified, Ed Gaskins, and Robert Helms; (standing) Dolph Black, Ralph Howell, Clifford McLean, Jenks Ellington, Henry Carriker, Bill Black, Robert Quillen, Eva Lee Hood, Jim Harper, unidentified, Link Robinson, unidentified, Norman Reynolds, and Check Hood.

James E. Harper helped lead the efforts to incorporate Mint Hill in 1971 to keep its identity and avoid being swallowed by Charlotte-Mecklenburg government. John McEwen was appointed mayor until the first election determined the town's leaders. A total of 22 candidates registered for an opportunity to govern Mint Hill, and 550 voters cast their ballots. Jim Harper, Robert Long, John McEwen, Jerry Mullis, and Anne Davis were the top runners. The five candidates decided that Robert Long (pictured) would act as the first elected mayor of Mint Hill.

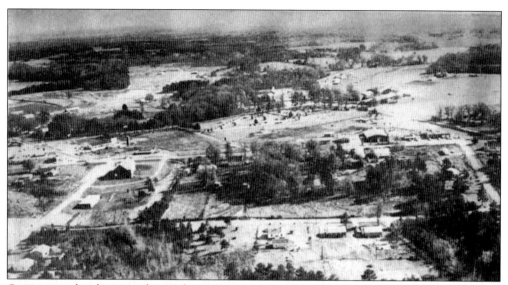

Community development during the 1960s resulted in this 1964 aerial view of Mint Hill, which shows Matthews–Mint Hill Road (horizontal road between Sunset and Hillside Drive) in the center of the picture. During this time, the community tried to improve its visual appeal as well as identify problem areas that needed attention.

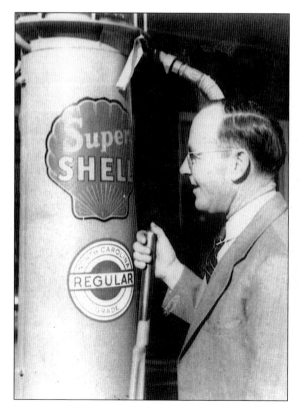

In the early 1920s, Dexter Marshall Lemmond (pictured here) opened a gas and grocery store on Albemarle Road in the Allen community near his home. When Dexter married Minnie Lowrance, a schoolteacher in 1936, the price of gas was about 13¢ per gallon. Their only child, Sue Lemmond, married Jerry Norris Helms. The building today is occupied by the Pottery Pad and retains its original exterior, interior shelving, Coke box, and other service station memorabilia.

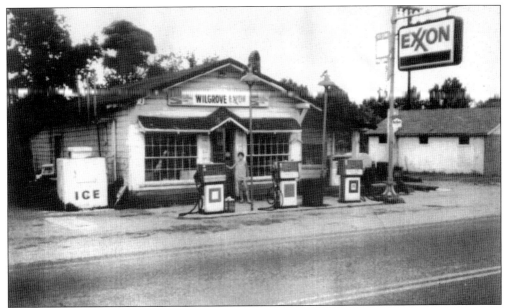

Joe Arant became manager of the Wilgrove Service Station in 1927 at the age of 16. He eventually purchased the business and increased services to include a meat and produce market, as well as general merchandise for home and farm. He continued to operate the business until the 1980s when Albemarle Road was widened. Joe, his wife, Letha, and children, Billy and JoAnn, lived in a house beside the store.

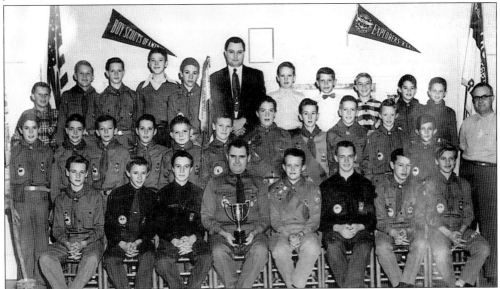

This 1953 photograph of Boy Scout Troop 65 of Philadelphia Presbyterian Church shows, from left to right, (front row) Clay Mullis, Charles Beard, Bill Cathey, Scoutmaster Robert Girard, Eddie Rushing, Wayne Bartlett, Barron Bartlett, and Fred Brown; (middle row) Hal Ross, Jack Earp, James McWhirter, Doug Hough, Gary Gray, Jerry Mullis, Olin Flowe, Steve Newell, Larry Stansell, Mike Hunter, Tom McWhirter, and Ross Cathey; (back row) unidentified, Dowd McEwen, John Black, unidentified, Buddy Corbett, Ray Waltman, Tony Harris, two unidentified scouts, Denny Allen, and Ted Harris.

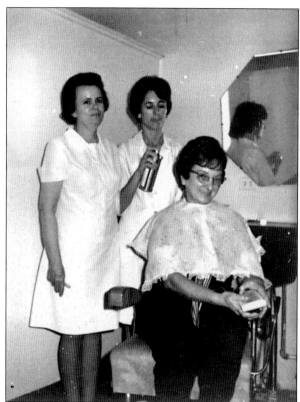

From 1945 to 1985, Rose's Beauty Salon was owned and operated by Rose McWhirter, wife of James McWhirter Jr. Her sister, Vera Tweed, and her sister-in-law, Henrietta McKay, assisted her in the shop, where they offered "machine and machineless permanents, cuts, cold waves, dyes and styling." Ladies are still having their hair done in the same location at Brenda's Beauty Shop on Matthews–Mint Hill Road.

In early 1950, Col. Robert Quillen was installed as first commander of the Earp-Williams VFW Post in Mint Hill. Dedicated to the memory of everyone who died in the service of their country, Post #4059 was named for Troy Earp and Everette Williams, two local servicemen who gave their lives for their country. Carl J. McEwen gave the land for the post, and members constructed the building using donated lumber.

Beamon Long joined the staff of the McEwen Funeral Home in 1932, followed by Lemuel "Lem" Long Jr. in 1937. A decade later, Beamon opened a black branch of the McEwen Funeral Home in Mint Hill and was assisted by Lem Long and William Aery. This picture shows the funeral home business located on Lawyers Road, just northwest of the McEwen Shopping Center.

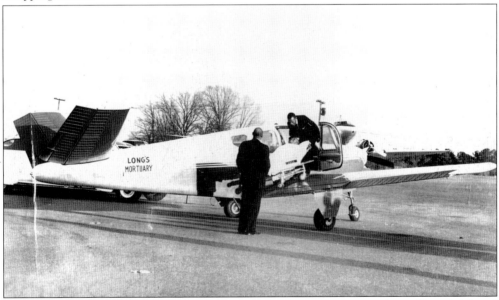

As reported in a 1956 edition of the *Charlotte News*, Beaman Long, president of Long's Mutual Burial Association, and Lem Long Jr., general manager, secretary, and treasurer of the association, strived to provide the best service possible, using the most modern equipment and services. An important feature of their service was the availability of an air ambulance flying to all areas of the United States.

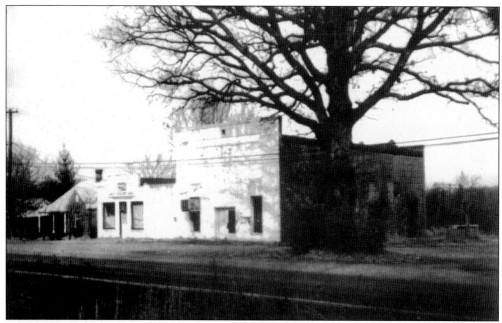

Eli Henderson's brick store, built in the late 19th century, was a general mercantile store where customers could shop for farm implements, seed, fertilizer, work clothes, boots, wash pots, and various household items. A roller mill for grinding flour was located on the second floor. With few alterations, this historical building is the home of O'Neil's today.

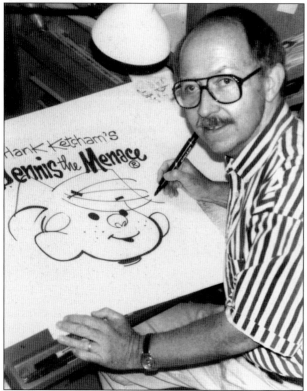

Marcus Hamilton, a gifted freelance artist and MHHS member, drew a rendering of the Dr. Ayer Whitley Museum for a brochure in 1989, and it then became the society's logo and the center of its seal. Since 1993, Hamilton has illustrated the *Dennis the Menace* daily panel that appears in syndicated newspapers all over the world. He works from a studio in the Mint Hill home that he shares with his wife, Kaye.

Paul Burch operated a pool hall in this building until he converted it to a grocery store in 1948. Stocked with a variety of canned goods, fresh bread, tobacco, candy, and other staples, he met the needs of local families. Paul and his wife, Virginia Biggers, lived with their two daughters, Paula and Pam, in the large two-story home next door. Originally owned by Eli Henderson, it was known as the Oscar Woods home.

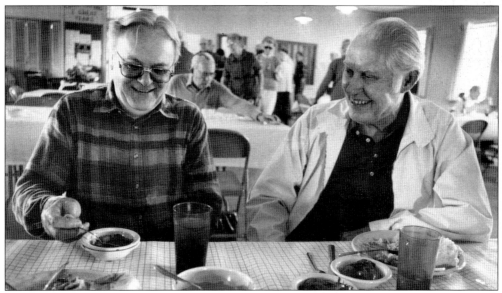

In this picture, Bob Long and Jim Black, good friends and business partners, enjoy a meal at the Senior Nutrition Program at Philadelphia Presbyterian Church after they and other community leaders were successful in persuading the county to start a program in Mint Hill. Lawyers Road Baptist and Blair Road Methodist Churches provided the first vans that picked up seniors who were unable to drive. Educational programs, entertainment, and fellowship continue to enrich the lives of those who attend the program.

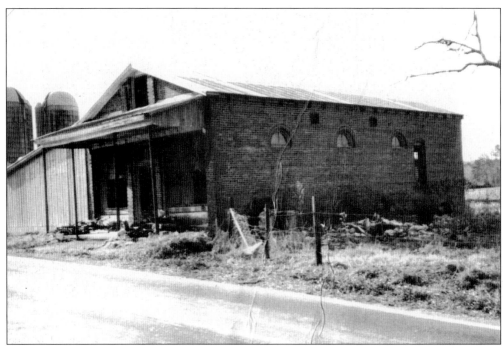

F. Martin Hinson, son of Eli Hinson, constructed the Hinson Store of handmade bricks on Arlington Church Road in 1900. The bricks were made on site, just as they were when the home across the road was built in 1786. The store closed when Martin died in 1935. Bryan Houston added the side additions and porch when he purchased the Hinson farm in 1946.

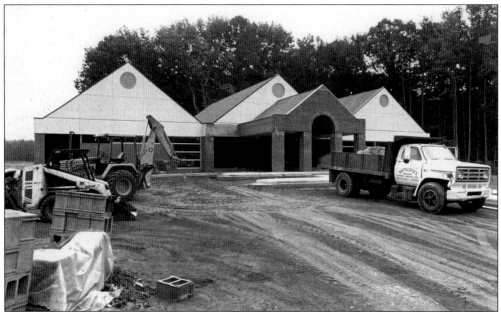

The Mint Hill Medical Care Center, shown under construction here, brought medical specialties such as pediatrics, obstetrics, gynecology, radiology, and internal medicine to the town, filling a void left by the departure of Drs. Charles Chrysler and John Dayton. Mayor Troy Pollard cut the ribbon when the center, now called Mint Hill Family Practice, opened in 1987.

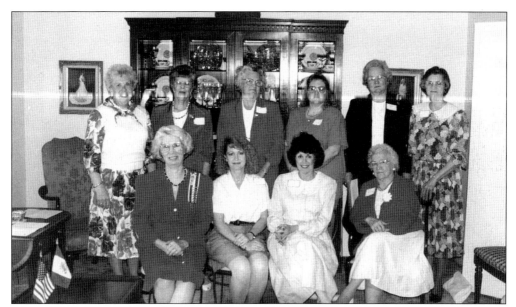

The Clear Creek Militia Chapter of the Daughters of the American Revolution held its organizational meeting in 1992, with charter members Grace Alexander, June Baucom, Althea Cole, Amelia Ford, Janet Gillette, Nancy Gordon, Tracy Gordon, Jeanne Hagen, Florence Hart, Betty Horne, Willie Houston, Carol Morgan, Marilyn Papciak, Ferne Sauers, Elloise Schottler, Shirley West, and Dorothy Wilkes in attendance. Dedicated to the worldwide service organization, the group sponsors good citizens at local high schools, honors veterans, and participates in the naturalization of new citizens. This picture was taken at a later meeting.

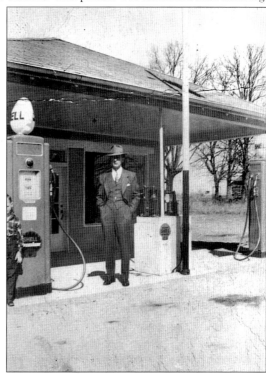

Bill Black built this station on Fairview Road in 1946 and operated it as a gas station and grocery store until 1952. His son John owned and operated the Mint Hill Five and Dime Store in the building from 1959 until 1977. The address on Fairview Road was then known as Mint Hill Road, East.

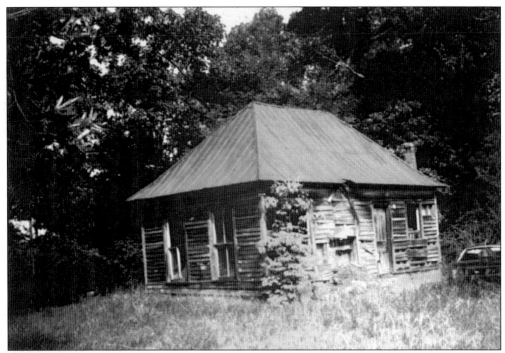

During the early 1800s, when gold was discovered in Mint Hill, miners brought their gold to this building near the Surface Hill Mine to be analyzed. The mine closed in the 1930s, and the W.L. Wilson family converted the assay office to a home. The Mint Hill Historical Society has received the building from the Wilson family and plans to move and restore the assay office.

Watson Morris operated a large dairy on Lebanon Road during the 1930s and 1940s. Though no longer a dairy, the property retains its farm-like setting. Fred Brown recalls that Morris worked 16 hours a day, 7 days a week, milking 94 cows twice a day by hand. Later, automatic milking machines were installed. Dairy operations in Mint Hill ceased in the 1950s.

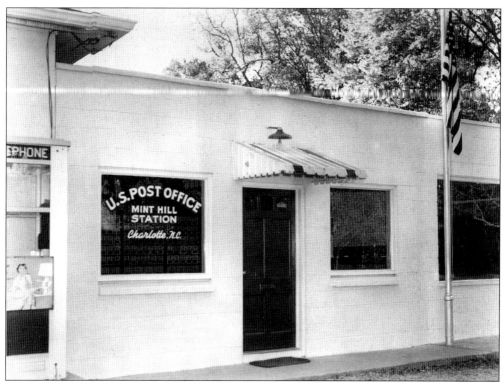

This contract station of the federal post office was located between Wither's Barbershop and John M. McEwen's General Store at the corner of Lawyers and Matthews–Mint Hill Road. Today the Carolina Creamery occupies the site.

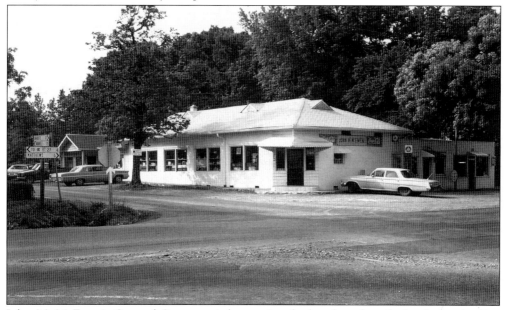

John M. McEwen's General Store carried groceries, feed and seed, nails, hardware supplies, high-top boots, concrete blocks, work clothes, and gasoline. His wife, Scottie, taught school, helped in the store, and later ran the Mint Hill Post Office next door for 18 years.

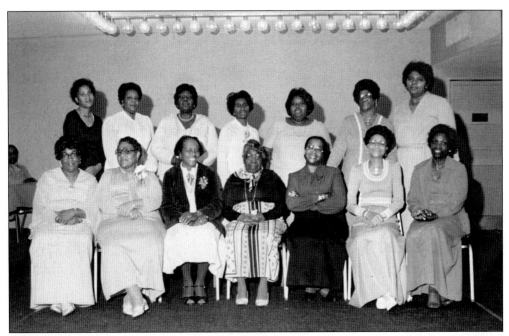

The Mint-Gunn Home Extension Club served the community by reaching out to schools and those in need. Pictured here from left to right are (front row) Odessa J. Helton, Myrtle Long, Hazeline Robinson, ? McCauley, Ruth Phifer, Lizzette Kiser, and Ada Gaston; (back row) Jessie Wallace, Evelyn Murphy, Viola Digsby, Jo Evelyn Liggett, ? Robinson, Sara Stafford, and Louise Helton.

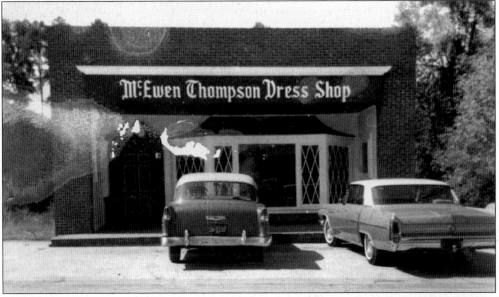

The McEwen Dress Shop had its start in the side rooms of the McEwen Funeral Home where dresses were made for the deceased to lie in state. In the 1940s, Mrs. Minnie Belle McEwen and Mrs. Lucille Thompson opened the McEwen-Thompson Dress Shop on Matthews–Mint Hill Road and sold dresses to the public. Women came from all over to shop at this unique dress shop with personalized service.

In 1936, Harold Marvin Mullis Sr., known as "Penny," founded Penny's Place. In addition to selling gas, he also sold hot dogs topped with wife Martha's homemade chili. Customers could toot their car horn for curb service. In 1948, the present building was constructed, providing room for pool tables and a food counter where the legendary hot dogs were served. After Penny retired in 1979, the pool tables were removed and tables and booths installed. Today, the Mullises' son-in-law Billy Kiser operates Penny's.

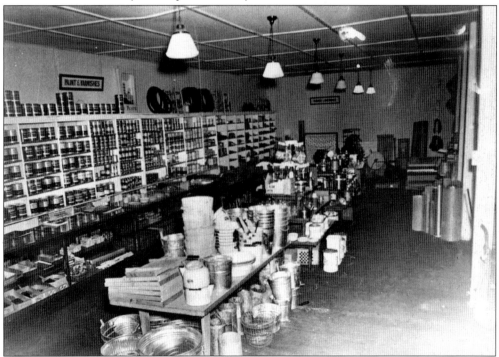

The inventory of McEwen Hardware Store included everything from washboards to bicycle tires. Charles H. Hunter and his wife, Frances (daughter of Carl and Minnie Belle McEwen), operated the store. Frances, who excelled in academics and sports at Bain High School, also served as president of McEwen Funeral Home.

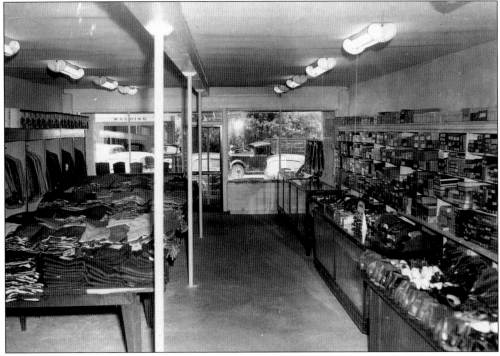

Clifford McLean began his clothing store for men and boys in the 1940s, selling pants, overalls, suits, shoes, ties, and accessories in the Carl McEwen complex. Customers could go from his store to the drug store and the grocery store without ever going outside. Clifford's wife, Treva, a seamstress, hemmed pants and did alterations. His daughter Doris and son Cliff Jr. were store clerks.

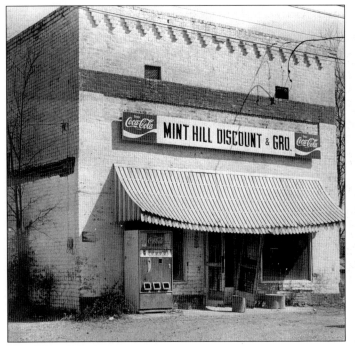

Believed to be the earliest commercial building in Mint Hill, this general mercantile store was built by Dallas A. Henderson in 1865 near the site, where Dr. John DeArmon later built his home. In 1900, the store on Fairview Road (the main street of town) was surrounded by beautiful homes. Several families, including the Estridges and Garlands, owned the store before Jimmy Allen made it the Mint Hill Discount Store.

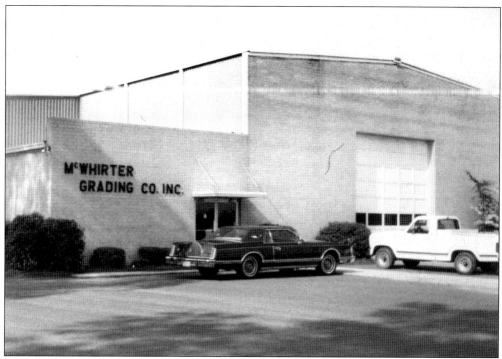

James W. McWhirter III started his family business in 1961 with one bulldozer, one trailer, and one truck. Today McWhirter Grading Company on Fairview Road has 100 employees and sends its fleet of trucks and heavy equipment to job sites all over North Carolina and into surrounding states.

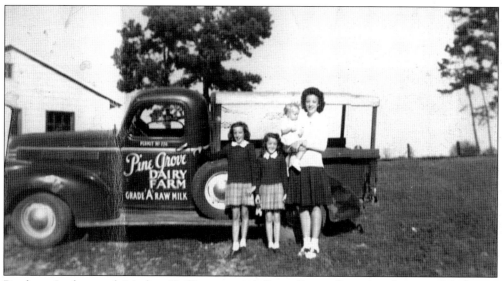

Brothers Luther and Marley Griffin operated Pine Grove Dairy on Lawyers Road near Thompson Road between 1938 and 1952. Marley's daughters, shown in front of the truck, are Annette, RoEna, Meldonna (baby), and Marguerite. The dairy delivered milk in glass quart bottles to homes in Charlotte and sold milk in stores for about 15¢ a quart.

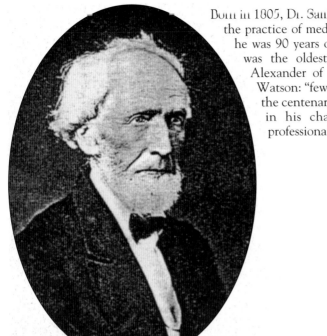

Born in 1805, Dr. Samuel B. Watson devoted his life to the practice of medicine in the Mint Hill area until he was 90 years old. At the time of his death, he was the oldest practitioner in the state. Dr. Alexander of Charlotte wrote this about Dr. Watson: "few persons have approached so near the centenarian in years with so few blemishes in his character considered either as a professional man, or a Christian."

The community welcomed Dr. Ayer Whitley (1884–1951) and his wife, Esther Calcenia Mangum (1884–1987), in 1908. Dr. Whitley was the son of Phillip and Mary Simpson Whitley of Union County. He not only saw patients in his office but also made house calls by buggy, motorcycle, and automobile. In his lifetime, Dr. Whitley delivered 6,784 babies, including 12 of his own. The fee for delivering a baby in 1908 was $3, plus $1.50 for travel expenses.

Dr. DeArmon's first day in Mint Hill was memorable for many. It was during one night in 1886 when the Charleston earthquake shook many from their beds. Dr. DeArmon (1857–1945) arrived on his skinny horse named Wallace, but with typhoid fever ravaging the town, there was no time to be daunted by the quake. He served the community for 21 years, and along with his wife, Susie Wolfe DeArmon (1868–1944), reared 12 children. In 1907, he moved his practice to Charlotte, where he was an outstanding figure in medical circles.

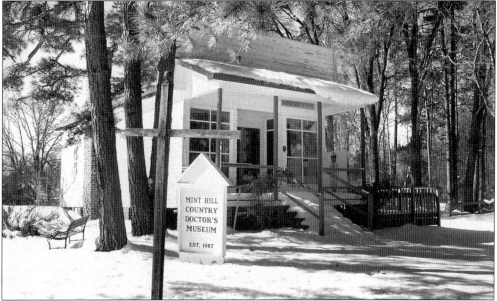

In 1985, Ayer Crouch Whitley Jr. donated the office where his grandfather, Dr. Ayer M. Whitley, practiced medicine. The building was moved to land donated by the Carl J. McEwen family and became the first of many restoration projects for the newly formed Mint Hill Historical Society. Visitors to the Mint Hill Country Doctors Museum now see a complete representation of rural doctor life, along with pharmaceutical displays, medical cabinetry, instruments, bottles, and journals that give a clear depiction of medical practices of the 1880–1930 period.

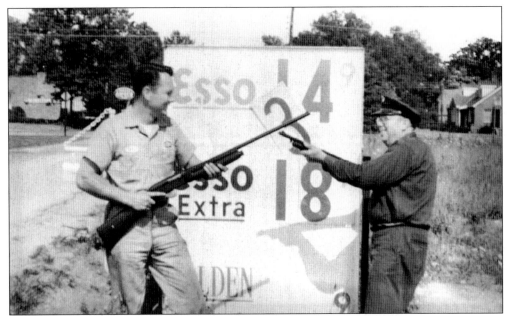

In 1954, Luther Griffin opened a full-service Esso service station, where Neil Thompson was the mechanic and Bus King greased and serviced cars. On Saturday, many young boys, including Luther's son Bill Griffin, washed cars, filled tanks, cleaned windshields, whisked floorboards, and collected money at the pump. This 1964 picture shows Evan Eudy, who worked across the street at the Amoco station, posing with Luther during a friendly gas war.

In 1958, Dan and Avery Hood opened the Lake Haven Ranch Camp, a day/residential camp for boys and girls. For three decades, thousands of children benefited from the hands-on camp experiences, which included auto mechanics and farm life education. An avowed supporter of music education, Dan also used his position on the school board to promote the arts in public schools.

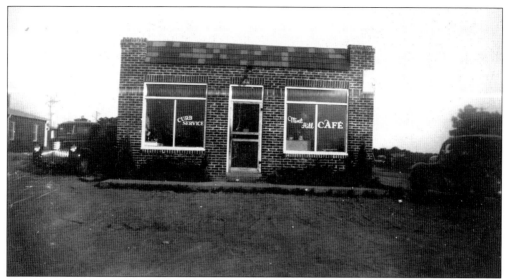

From 1942 until 1946, Marley Yates Griffin and Eula Mae Purser Griffin operated the Mint Hill Café, where customers ordered hamburgers and hotdogs, sipped sodas, and listened to the juke box. The Griffins even offered curb service. Later, Ross Florist, owned by Sarah and Pernay Ross, occupied the building on Matthews–Mint Hill Road. The building is now the home of Woof N Hoof.

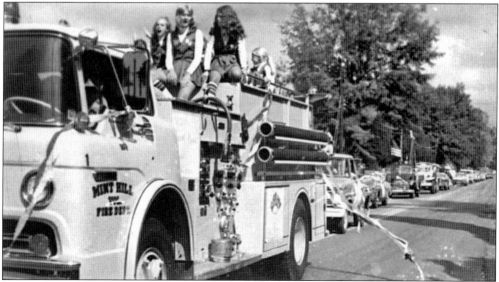

The first Mint Hill Madness, organized by the Mint Hill Business Association (MHBA) for the benefit of the community, debuted in the spring of 1983. More than 15,000 were reported in attendance, and shuttles ran between athletic and entertainment events at Bain School and Hoods Crossing. The MHBA continues to sponsor this event, now held at the Mint Hill Park on Fairview.

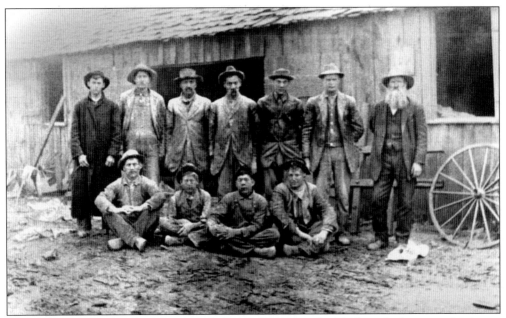

John Nisbet Rodgers is shown here with his employees at the blacksmith shop near his home in the Albemarle Road and Dulin's Grove Church area. After losing his right arm in an accident, Rodgers was known as the "one arm blacksmith." He was also the schoolmaster at the Arlington School.

As owner of Wilson's Food and Drug Sundries, located at the corner of Matthews–Mint Hill and Lawyers Roads, Olin Wilson served the citizens of Mint Hill for over 30 years after purchasing the business from Carl J. McEwen in 1935. He enjoyed the children who stopped by after school each day for a bottled or carbonated drink, milkshake, or huge scoop of Pet Ice Cream from the fountain. He also helped his customers with hair products, thread, magazines, comic books, medicines, toys, and candy.

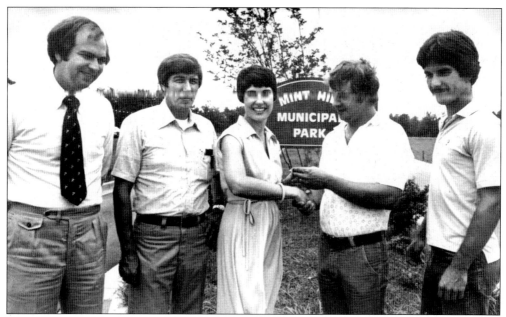

Mint Hill's first Municipal Park, developed on 15 acres of land on Wilgrove–Mint Hill Road, features tennis courts, basketball goals, picnic tables, outdoor grills, and a playground. Pictured here in 1978 from left to right are town administrator Steven Foster, Mayor Troy Pollard, Sharon Doar, Dr. Ken Koontz, and Tad Baucom, Mint Hill's first park director.

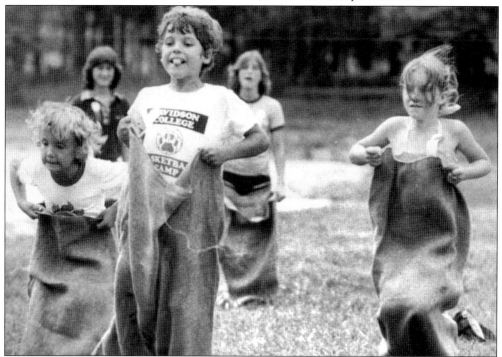

These children enjoyed old-time sack races in the town's first Municipal Park on Wilgrove–Mint Hill Road. Land for the park was purchased in 1976 from James E. Harper, a town board member and leader in the movement to incorporate Mint Hill.

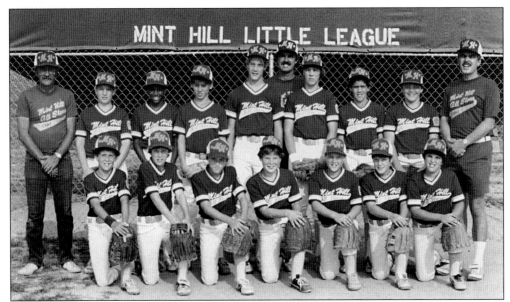

Little League Baseball, a program of the Mint Hill Athletic Association (formed in 1973), has impacted the lives of hundreds of young people in Mint Hill and resulted in three state championships. Pictured in this 1980 team, from left to right, are (front row) Brad Tobias, Todd Holmes, Al Wingate, John Skeen, Ron Snell, Patrick Griffin, and Kirk Harris; (back row) Coach Charlie Miller, Jeremy Hough, Cornell Caldwell, Will Quiring, John Bryan, Manager Jerry Flowe, John Russell, Ashley Shutze, David Renfroe, and Coach Tom Shutze.

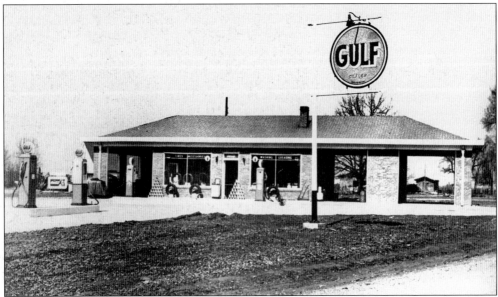

In 1946, Carl McEwen built this service station at Fairview Road and Matthews–Mint Hill Road, and his son-in-law Lester Anderson operated it for several years. (Clegg Mullis got his on-the-job training there before starting his own business across the street.) J.Z. Earp owned and operated the service station from 1952 until 1967, at which time his son Johnny took it over. Chad and Dickie Earp, Johnny's sons, operate the station today as a BP convenience store. Gulf, Amoco, and Texaco products have been sold at the station over the years.

Mint Hill's blacksmith shop, seen here around 1940, sat beside Dr. Whitley's office on Fairview Road. Horses kicking as they were being shod made dents in the metal building. A man named Haskell served as one of the first blacksmiths, and his wife, Pearl, worked for Link and Evelyn Robinson, who provided room and board for Bain School teachers. Charlie Franklin Bogans, a Red Branch Church member, was another blacksmith. The young girl in the picture is Peggy Henderson, daughter of Don and Mae Henderson.

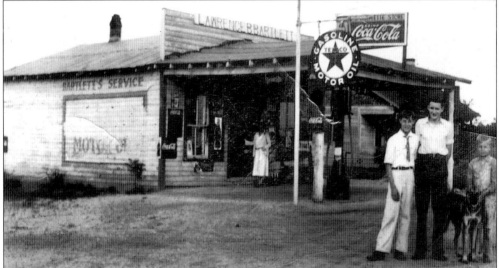

Lawrence Burdett Bartlett opened this store on the corner of Fairview Road and Bartlett Road in the 1930s and operated it with his wife, Rachel Moser Bartlett, and their three sons. Gas was pumped from an underground tank to a 10-gallon glass container atop the pump (featuring numbers representing gallons of gas in the tank), and a handle on the hose allowed the gas to flow by gravity into the gas tank of a car. Mr. Bartlett eventually turned the store over to his oldest son, Philip E. Bartlett. The young boy, shown in the picture with the German shepherd, is Aubrey M. Bartlett, the middle son, and the lady is his mother. The other boys in the picture are unidentified.

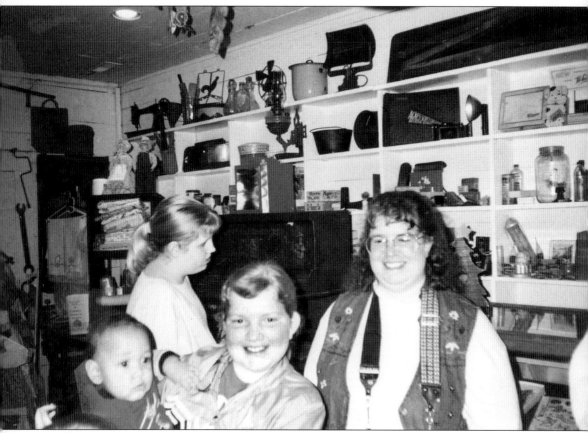

Built in 1916 by Ira V. Ferguson, this country store was moved to Hillside Drive after being donated to the Mint Hill Historical Society in 1996 by Ira's son Aaron. The restored building includes the stone cellar, where Ira kept the soda and tobacco cool, and features the counter and original shelving, which held fabrics, candies, household goods, and tools. The store also contains the barred window from the original Mint Hill Post Office.

Three
SCHOOLS AND CHURCHES

The name of Bain School changed over time—from Bain Academy to Bain High School to Bain Junior High and finally Bain Elementary. John Bain established the school and later donated it to Philadelphia Presbyterian Church, which oversaw its operation. Students paid $10 per month for room and board at nearby homes with tuition varying from $1 to $3.25 per month, depending on student grade level.

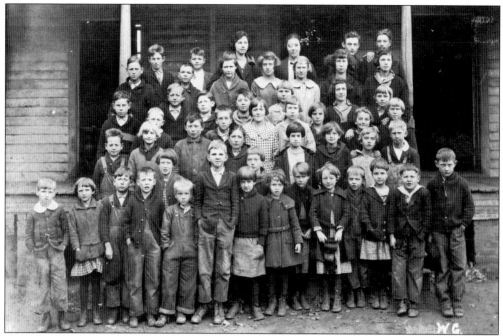
These Wilson Grove School students are shown with Annie Davis, their teacher.

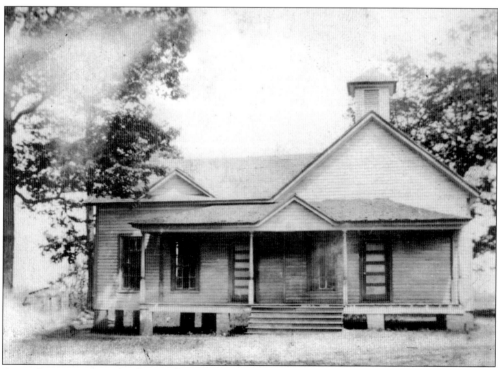
According to a 1911 postal map, the Wilson Grove School was located across the road from the Wilson Grove Baptist Church on Wilgrove–Mint Hill Road.

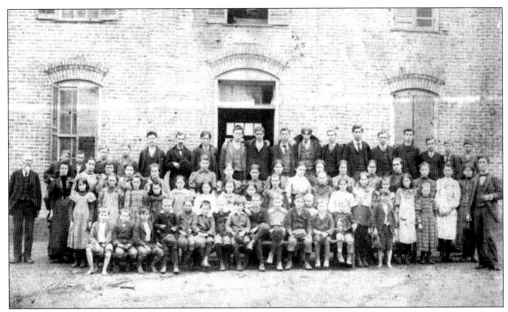

Students and teachers at Bain Academy pose proudly with their founder, John Bain, pictured at the far left. Bain (1808–1897) was 80 years old when he organized the work force that would complete the brick schoolhouse in time for classes in 1889. His epitaph reads: "John Bain, the builder of Bain Academy, donated it to Philadelphia Presbyterian Church in 1889. Long may his name live." John Bain is still remembered over 100 years later.

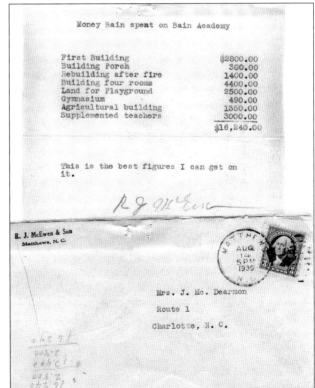

A letter addressed to "Mrs. J. Mc. DeArmon" from R.J. McEwen and postmarked August 14, 1936, reveals an accounting of money used to build Bain Academy. The postmark on the envelope indicates Matthews as the post office for R.J.'s mail in Mint Hill.

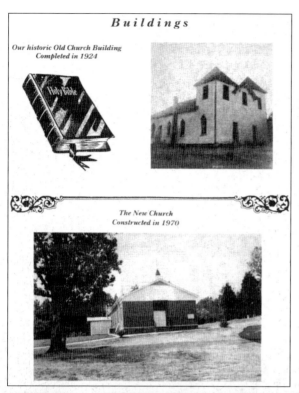

Red Branch Missionary Baptist Church, an outgrowth of the Salem Hill Presbyterian Church in the Arlington community, held its first service on the fourth Sunday in September of 1866, one year after President Lincoln freed the slaves in the South. The church's first building was an old schoolhouse located on one acre of land, which they purchased from the county school board.

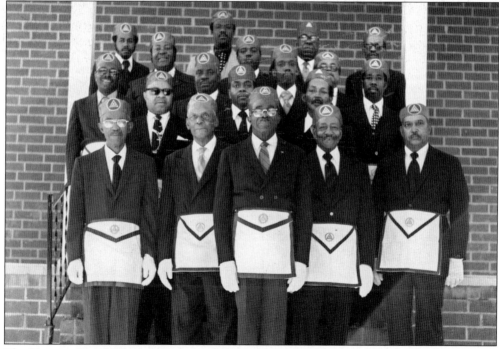

The Heart to Hand Mason group served the community from their lodge at the Red Branch Missionary Baptist Church. Three of the masons identified in this picture are Wilbert Alexander, Clarence Brown, and Charlie F. Bogans.

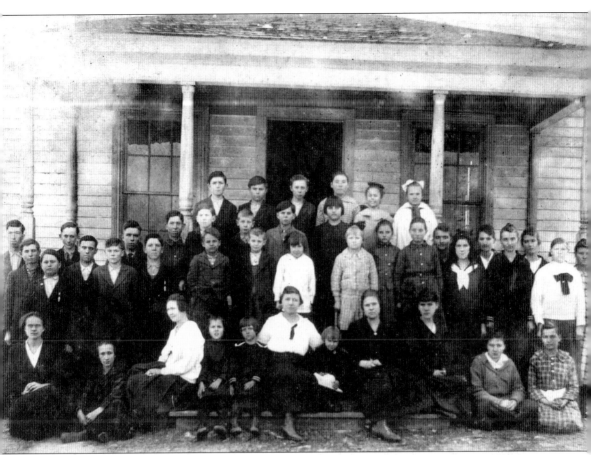

Teacher Irene Garmon, wearing a white blouse and black tie, sat among students in the front row at the Little Clear Creek School on Brief Road, where Albert Jerome "Doc" Garmon, her brother, was the principal. Some students identified in this *c.* 1917 picture were brothers Rufus and Berry Mullis, Neal Ferguson, McCamie Mullis, Catherine Reeder, Minnie Mullis, and Lou Wilson.

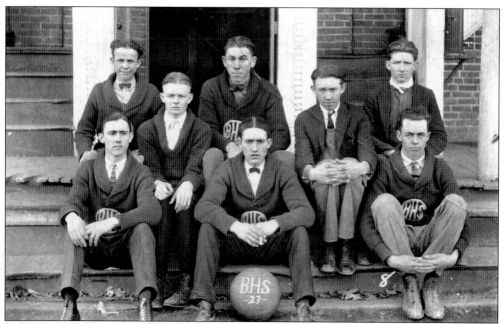

In 1923, the trophy for the county basketball champions went to the boys at Bain High School. Shown here, from left to right are (front row) Bill Wilson, Lee Wilson, and John McEwen; (middle row) Dwight Medlin and Sam Kessiah; (back row) Barney Huntley, Dowd McEwen, and Neal Harkey.

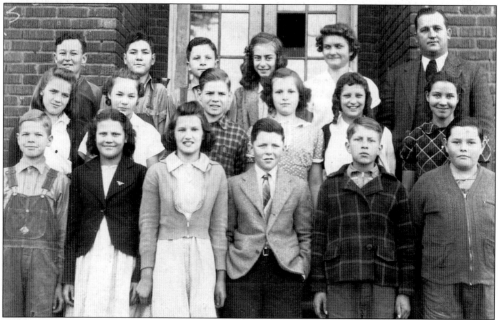

The sixth-grade students of Clear Creek posed for this picture in 1942. They are, from left to right, (front row) Merle Pigg, Doris Mullis, ? Pinion, Lee Flowe, ? Price, and Benny Davis; (middle row) Betty Bostic, Edith Williams, Jack Lee, Marjorie Hough, Annie Carriker, and Rachel McRae; (back row) Charles Cross, Edward Willis, Melvin Mullis, Martha Stansell, Elizabeth McManus, and Principal Quincy Gregory.

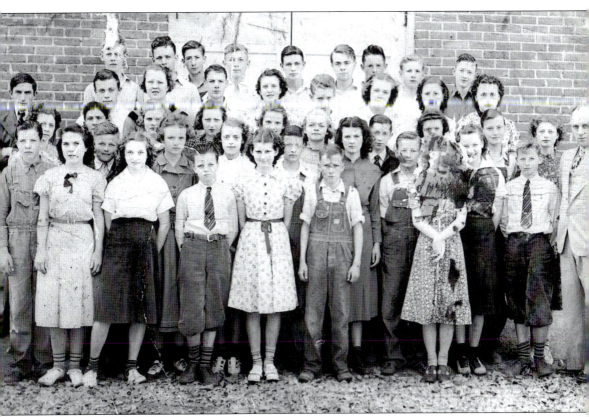

Pictured are the 1938 eighth-grade students at Bain School. Pictured from left to right are (first row) Blanche Ferguson, Eleanor Moser, Ted Brafford, Ann Louise Helms, Hubert Williams, and Eloise Lemmond; (second row) Johnny Mullis, Alva Mullis Jr., Loraine McWhirter, Tharzia Vaughn, J.Z. Benton, Marybelle Mullis, Aubrey Bartlett, Sue Allen, Hal Brafford, and ? Harrington (teacher); (third row) Thelma Phillips, Ray V. Ferguson, Mary Haigler, Wileen Wilson, Judy Flowe, Rosella Henderson, Bill Campbell, Margie Mullis, Dowd Mullis, and Burlene Yandle; (fourth row) Robert Quillen (teacher), Gene Byrun, unidentified, Ted Mullis, Eddie Mullis, Carl Jordan, Edith Haigler, Mildred Dulin, and Margaret Flowe; (fifth row) Everett Wilson, Harlen Bartlett, ? Long, J.W. Dennis, Morris Benton, Zeb McManus, Morris Reynolds, Bruce Thompson, and Ray Daniel Mullis.

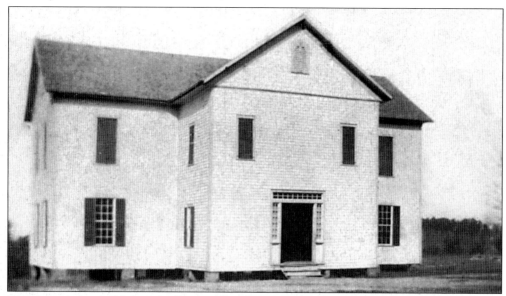

The congregation of Arlington Baptist Church met in October 1899 to discuss the need for a school in the area. A motion was made and approved, and in 1902, the Arlington School was established and built beside the sanctuary. Students from miles away attended this school until Clear Creek School replaced it in 1924. Two students who remembered attending Arlington School were James Flowe and Verda Brafford.

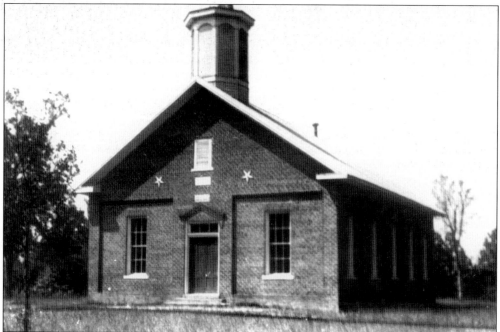

At the end of the Civil War, Eli Hinson returned home with a desire to begin a church. He and his family, with several other families, began worshiping in a brush arbor and later met in an old tenant house. In 1875, the First Arlington Baptist Church was built, followed by a second sanctuary in 1884—still in use. The name "Arlington" was chosen from a hymn that was often sung during worship services.

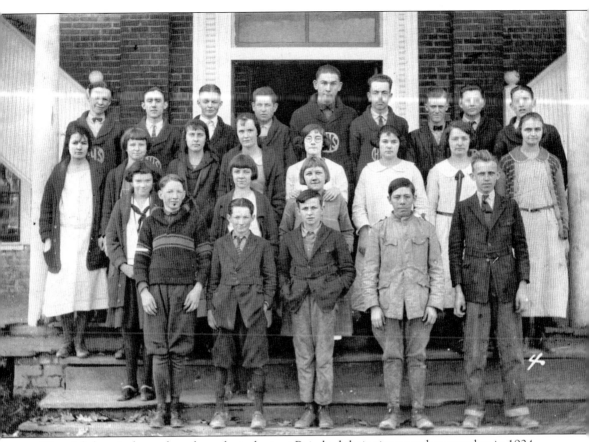

The eighth-, ninth-, and tenth-grade students at Bain had their pictures taken together in 1924. Included here from left to right are (first row) Evans Brown, Ayer Crouch Whitley, unidentified, Mack Long, and Carl Wilson; (second row) Margaret Biggers, Grace Long, and Bleeka McEwen; (third row) Annie Mae Benton, unidentified, Wilma McEwen, Ruth Mann, Rena Mae Junker, Leone Long, Mae Bartlett, and Louise McWhirter; (fourth row) Barney Huntley, Bill Wilson, Dwight Medlin, D.W. Flow, Dowd McEwen, John McEwen, Brice Griffin, Ned Dorton, and Lee Wilson.

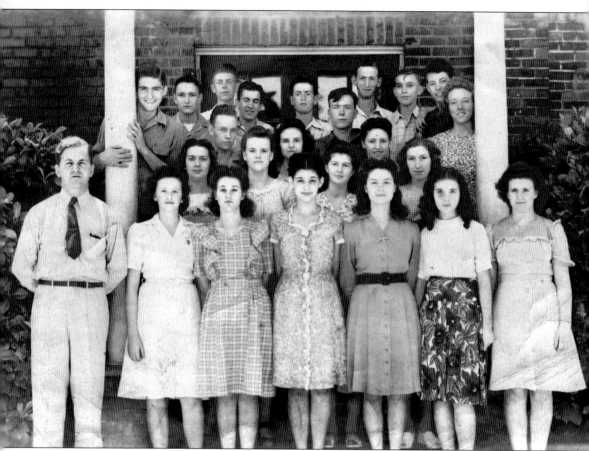

The 1947 senior class of Bain High School posed with Herman Gaddy, principal and teacher. Shown from left to right are the following: (front row) Gaddy, Dorothy Hough, Frances Hagler, Peggy Flowe Graham, Bonnie Kiser Benton, Carol Lemmon Hill, and Daisy Dennis Benton; (middle row) Jean Dennis Price, Devore Carriker, Evelyn McWhirter Flowe, Bernice Mullis Penninger, Eloise Long Hagler, Lee Douglas Flowe, Betty Osborne, Geraldine Rowell Auten, and Ola Mullis Williams; (back row) Joe Connell, Dowd Morris, Bruce Campbell, Ray Benton, Erskine Phillips, S.D. Wilson, Eugene Hill, and Max Williams.

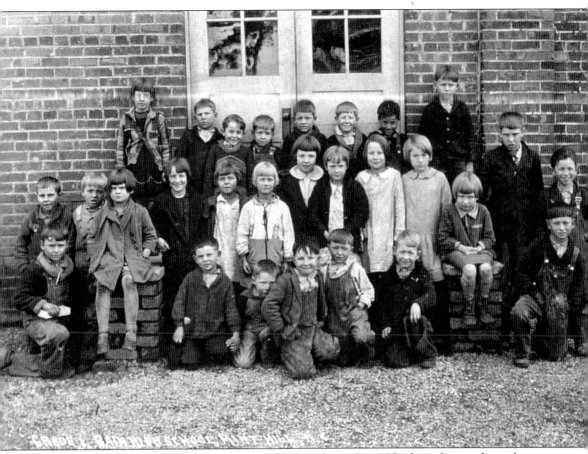

Bain High School was not just for high school students. In 1925, these first-grade students posed for their class picture. Shown from left to right are (front row) Hazel Garland, Sam Whitley, Sam Dulin, Walter Earp, and Walter Woods; (middle row) Joe Morris, two unidentified boys (behind Morris), Mary Mullis, Frances Campbell, Sara Dennis, Dorothy Mullis, Margaret Mullis, Lillian Rushing, Dorothy Dulin, Lena Dorton, unidentified, and Daltin Benton; (back row) Helen McEwen, E.C. Thompson, Boykin Williams, Phillip Bartlett, Arnold Bartlett, Frank Campbell, Bill Long, James McCall, Clyde Crump, and Penny Mullis.

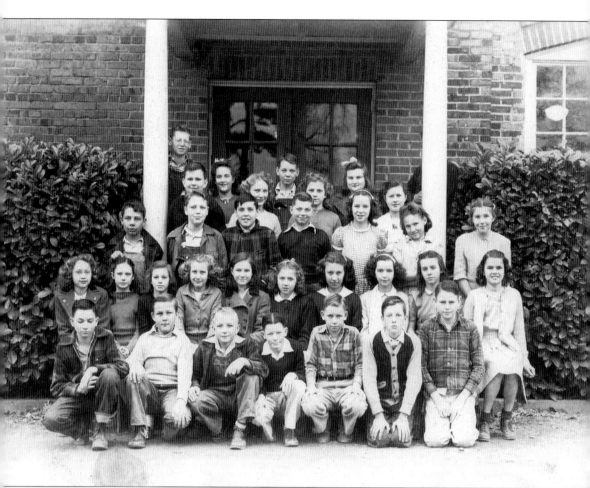

These Bain School students in 1940, pictured here from left to right, are (first row) Joe Hall, Luther Goble, Jerry Evans, Jerry Benton, James Mullis, Charles Carriker, and Leroy McManus; (second row) Kathryn Baucom, Patsy Allen, Minnie Belle Dulin, Georgia Anna Fesperman, Elizabeth Page, Clair Houston, Polly Allen, Jewell Huntley, Joyce Dulin, and Jean Ross; (third row) Jake Long, Melvin Carriker, Wade Conder, Waddell Wilson, Evelyn Flowe, Peggy Helms, and Aleen Pigg; (fourth row) O.D. Watts, Frances Wilson, Vera McCall, and Margaret Linker; (fifth row) Bill Beck, Martha Dennis, Bobby Long, Geraldine Presson, and Doug Benton.

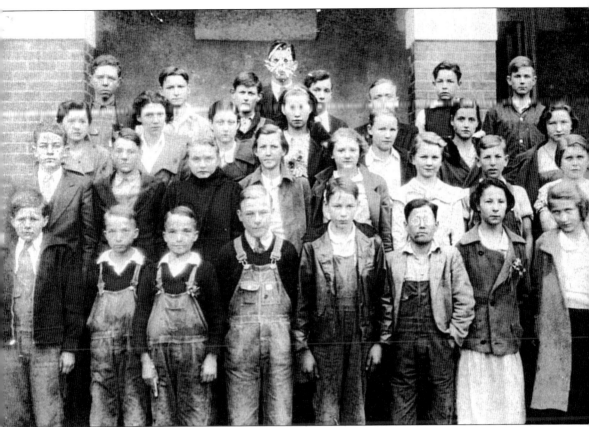

The Bain School students pictured here in 1930 are, from left to right (first row) Philip Bartlett, Dexter Bowen, Baxter Bowen, C.M. Fite, Frank McCall, Bill Long, Myrtle Reid Steele, and Shirley Garmon; (second row) Boykin Williams, Olin Mullis, Helen Mullis, Helen McEwen, Lillian Rushing, Geraldine Black, E.C. Thompson, and Edna Ferguson; (third row) unidentified, Leela Tucker, ? Brattain, Zelda Wilson, unidentified, and Zelda Mullis; (fourth row) Perry Ferguson, Joe Morris, unidentified, Bueford Mullis, David Lee Dulin, and Donald Bartlett.

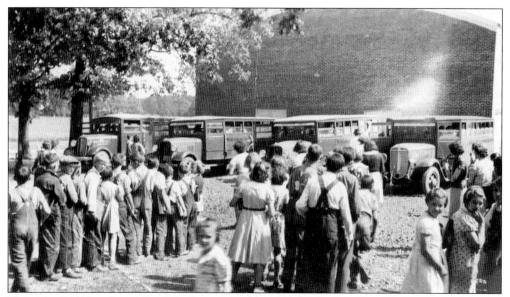

These students lined up to load the "square" buses parked in front of the Bain High School gym. Built in 1934, the gymnasium was taken down in 1969.

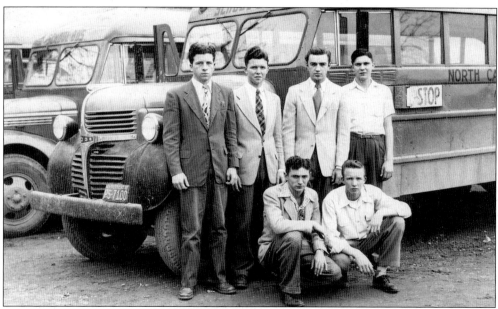

As schools consolidated in 1920, buses became necessary to transport children to and from school. Some students in high schools were excused from classes to drive their routes. Pictured from left to right in front of a 1941 Dodge bus are 1948 Bain High School bus drivers (standing) Melvin Mullis, Lee Flowe, Doug Ross, and Ned Ferguson; (stooping) Bill Wentz and Dewane Huntley.

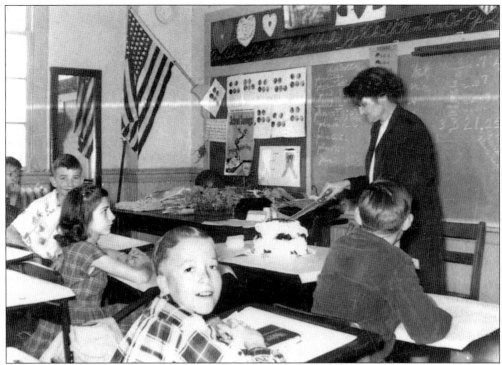

In all her years at Bain School, Minnie Lemmond was a favorite sixth-grade teacher. Known for living and teaching the "golden rule," Mrs. Lemmond's students have fond memories of the days they sat in her classroom, including Bill Griffin, who appears very happy that the Valentine's Day cake is finally being cut.

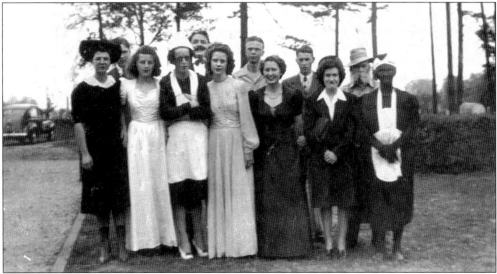

It was tradition that senior students at Bain High School present a play for the community at the end of the school year. The 1944 class play was called *For Pete's Sake*. Players, from left to right, included Eloise Phillips, John Williams, Betty Jean Long, Henry Reynolds, Ralph Ross, Martha Lee Wallace, Aaron Ferguson, Betty Garmon, Doyle McManus, Virginia Connell, Ranson Lee, and Edna Earl Whitley.

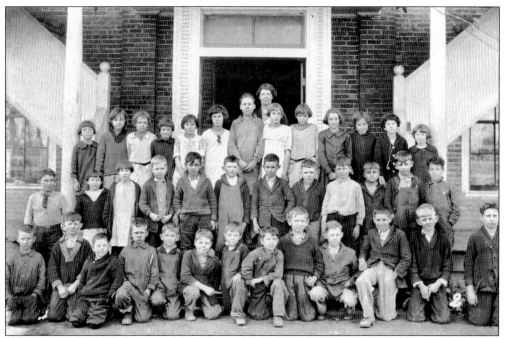

Pictured are students at Bain High School in 1923. Shown from left to right are (first row) unidentified, Clarence Mullis, Ike Garland, unidentified, J.R. Mullis, P.A. Wilson, Junior Hough, Lloyd Long, Robert Allen, Walter Linker, J.B. Osborne, Rozelle Mullis, and Albert McCall; (second row) unidentified, Harriett Brown, Margaret Forbis, Harry Ashcraft, Dolph Black, Woodrow Allen, ? Parrish, Wilber Todd, Philip Whitley, Tom Stalling, Jenks Ellington, and Martin Long; (third row) Hallie Huntley, Bessie McCall, unidentified, Lola Griffin, unidentified, Maybelle Osborne, unidentified, Cennie Parrish, and five unidentified students; (fourth row) teacher Miss Query.

In 1973, the Mint Hill Church of God met at Northeast Junior High School and organized with 21 members. In November of the same year, property was purchased on Bain School Road, and the congregation met in a mobile chapel until their fellowship hall was completed. The fellowship hall was used for services until the present church building was dedicated in 1990.

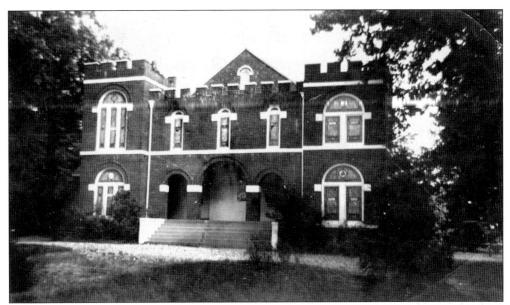

One of the original Colonial churches of Mecklenburg County, Philadelphia Presbyterian Church began organizing in the 1760s. The Rocky Spring Burial Ground on Brief Road marks the first location. After fire destroyed the original church, where three signers of the Mecklenburg Declaration of Independence worshipped, a second church was built in 1780 on Matthews–Mint Hill Road. In 1826, another meeting house was built on Bain School Road, the church's present location. The "tower front" on the church was part of the 1915 renovation.

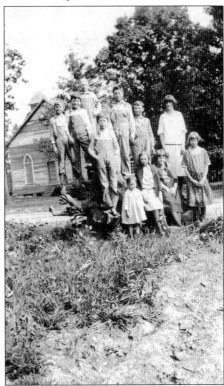

Children in the Wilgrove area posed around a root stump for this picture. The rear entrance to Wilson Grove Baptist Church can be seen in the background.

William Bain signed this agreement in 1830 or 1836 (with spelling as it appears in document): "to teach an English School Reading Writing & Arithmetic as far as he is capable . . . the School to concist of Twenty Five Schollars. . . . The Subscribers do agree to pay . . . Two Dollars pr Schollar for his Services." Some of the "subscribers," whose signatures appear as spelled, are Cyrus Query, Wm. Query, James Dulin, John Wilson, Rice Dulin, James McCombs, Hugh Wilson, James McCall, Wm. Foard, Zebulon Morris, Wm. L. Dulin, and Thos. Dulin.

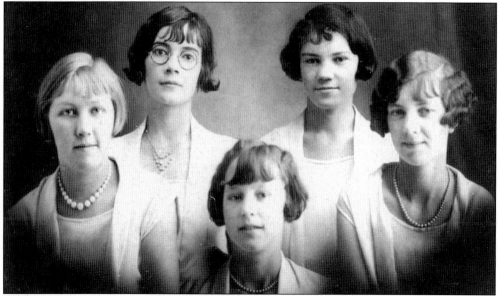

Bain High School's 1928 senior class of girls is featured in this picture, which includes Bleeka McEwen, Rena Mae Junker (with glasses), and Margaret Biggers.

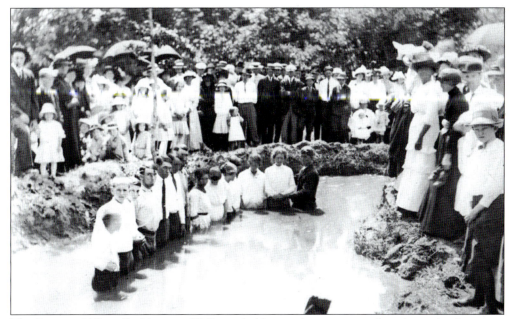

The Reverend Elam Cuthbertson Williams held revival meetings under a big red oak tree on Ferguson Road, with baptisms in a nearby creek. This led to the organization of Clear Creek Baptist Church in 1858 and the building of a sanctuary on land given by Jane Ferguson. Members in this 1913 baptism are Ida James, Mae Garland, Nannie Pigg, Lillie Robinson, ? Simpson, Bud Mullis, Reuben James, Bruce Hagler, Baxter Mullis, Roy Estridge, Murray Pigg, and David Benton.

It was the Roaring Twenties that influenced the drop-waist dresses and short haircuts on these students at Bain High School. Identified in this picture are Mamie Estridge (left) and Louise Long (second from left) in the second row. In the front row (left) is Helen Ashcraft, whose grandfather Walter Ashcraft built the Ashcraft Schoolhouse.

In 1923, the Flowe, Arlington, and Allen School Districts voted to consolidate and build a new school called Clear Creek High School, which opened for classes in November 1924, with an enrollment of 160 students. Teachers included W.W. McComb, principal; Cora Bell, Perrye Hallman, Maranda Biggers, Lenora Hipp, Annie Mae Hayes, and Mrs. Oscar Flowe. County educators organized sewing lessons, a poultry club, and a "Little Mother's League" at this school.

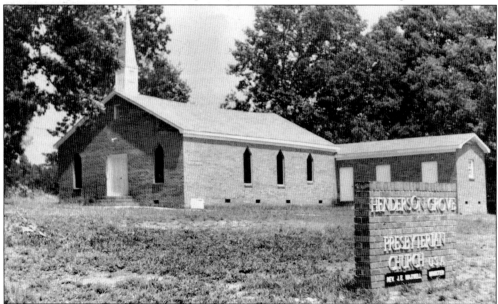

In 1901, members from the original congregation of Salem Baptist Church in the Arlington community split away from the church. Part of the group formed Red Branch Baptist Church, while the others formed the Salem Missionary Presbyterian Church (later Mint Hill Presbyterian Church). In 1911, the name changed to Henderson Grove in honor of Dallas Henderson, who sold the church their first acre of land. Before moving to the Blair Road site, the church was located on Lawyers and Bain School Road.

Organized in 1835 and rebuilt in 1917, Bethel A.M.E. Zion Church on Lebanon Road has a very rich history. Some markers in the cemetery date to 1910. Around 1978, the church burned and was reconstructed by many friends. A corner marker on the front of the church reads: "Erected to the Glory of God by PTL members and friends in 1976."

John Howard Cosby Flow and his wife, Margaret Charlotte Morgan Flow, deeded one acre of land to the county board of education in 1910 for the building of Little Clear Creek School on Brief Road. The county paid $25 for the property, and the Flow family regained their land for $10 in 1928 when rural schools were consolidated.

In 1965, the county purchased 65 acres of land from the R.J. Ingram family for $65,650 to build Independence Senior High School. The school opened in 1966 with a registration of 250 seniors, 300 juniors, 310 sophomores, and 57 teachers. In the school's mall, the Patriots proudly display the school cannon, won in a contest sponsored by the Lay's Meat Products Company.

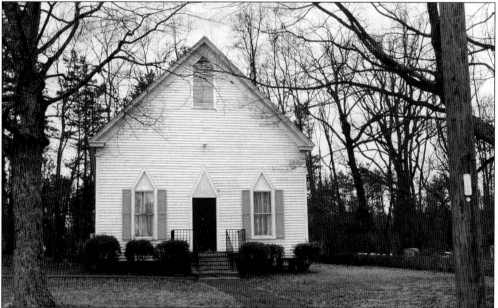

The year 1775 is the accepted organization date of Morningstar Lutheran Church, making it nearly 100 years older than the next oldest Lutheran church in Mecklenburg County. Originally known as Crooked Creek and then McCobbins Creek, the church's roots began in St. John's Church in Cabarrus County. This 1906 church building served the congregation until larger facilities were built nearby.

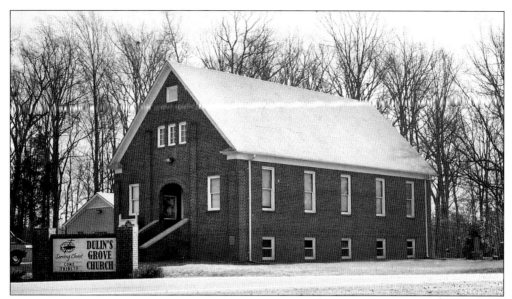

In 1893, Ambrose Dulin donated an acre of land with a beautiful oak grove for a church that would be named Dulin's Grove Advent Christian Church, with the Reverend John King as the first pastor. In 1933, a brick building was constructed nearby. The present church was built in 1976.

Shiloh Truelight Church in Mint Hill was organized c. 1900. Members had to build a new meeting house in 1956 when the church was struck by lightning and burned to the ground. Teaching elders have included Brother Melton Culpepper Mullis, Brother James Alexander Griffin, Brother Edd Harrison Mullis, and Brother James Rommie Purser. The church today has an extensive vocational school for children where skills such as bricklaying, woodworking, farming, and needlecrafts are taught.

Fr. Joe Mulligan was the founding pastor of Saint Luke's first parish home, located in a storefront at the Mint Hill Festival Shopping Center. For the next seven years, the parish worshipped, worked, played, and celebrated there. In 1994, a beautiful church was built on Lawyers Road. Administration and education buildings have since been added to serve the parishioners.

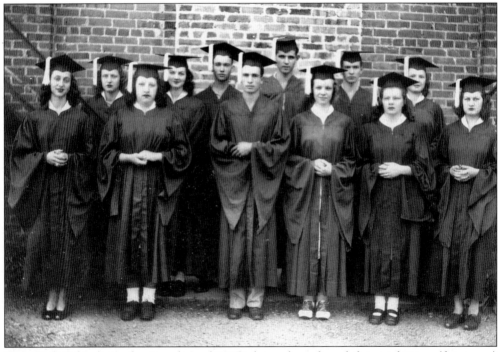

Bain High School's graduating class of 1945, shown here from left to right, are (front row) Johnnie Ellington, Annie Tompkins, Calvin Benton, Nadine Carriker, Catherine Price, and Myrtle Moser; (back row) Liller Jane Burnette, Amelia Robinson, Melvin Williams, Robert McCall, James Lloyd Connell, and Eloise Ross.

Raymell Henderson Williams kept the 1942 announcement listing the students in her graduating class, 13 of whom attended the 45th class reunion at Idlewild Country Club. Pictured from left to right are (front row) Norman Reynolds, Marie Earp Freeman, Catherine McCall Thompson, Raymell Henderson Williams, Josephine Williams Bird, Kenneth Griffin, and Charlie Burnett; (back row) Dorothy Thompson Richie, Bruce Wilkinson, William Flowe, E.T. Windham, Harold Mullis, and Charlie Flowe.

The 1942 graduating class of Bain High School poses here with their two young mascots. Included from left to right are (front row) Marie Earp, Catherine McCall, mascot G.V. Baucom, mascot Star Carriker, Raymell Henderson, and Stella Huntley; (middle row) Caroline Edwards (teacher), Elma Stegall, Kenneth Griffin, Charlie Burnett, Macie Hagler, Dorothy Thompson, and Norman Reynolds; (back row) Bruce Wilkinson, Eva Lee Rowell, William Flowe, E.T. Windham, Harold Mullis, Herman Bartlett, and Charlie Flowe.

123

In 1947, the Mecklenburg Baptist Association Mission Committee determined that a Baptist mission should be established in Mint Hill. Revivals were held and the mission began meeting at Bain High School's auditorium. Penny Mullis donated some of the land where the present church sits. Barracks from the vacated Camp Greene Army Base in Charlotte were brought to the site for temporary housing. The sanctuary for Mint Hill Baptist was built in 1952, and improvements were made to meet the needs of their increasing membership.

The original site for the first worship services for Wilson Grove Baptist Church in 1881 was in a grove of trees called a stand or bush arbor. The Reverend Elem Williams led the church's organization, and a small frame building was erected on land donated by Ang Wilson in 1885. Church members met one weekend a month, with preaching on Saturday afternoon and Sunday morning. In 1944, a new church was built across the street from the original building and cemetery. The present building was constructed in 1958.

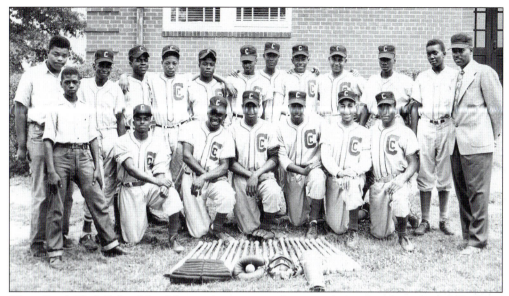

Clear Creek High School for African-American students was located at the present J.H. Gunn School. Nathan Jerome Black (first on the left, kneeling) is shown here with baseball teammates around 1950. The original schoolhouse built in 1925 was a wood-framed building called the Clear Creek Colored Union School. The school closed in 1966 and for a time became the school system's central office. In 1970, the school reopened as Northeast Junior High until Northeast moved to Brickstone Drive in 1976.

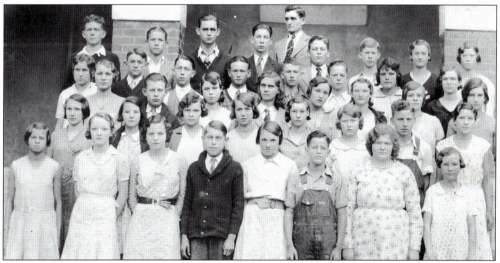

Pictured here from left to right are students and the principal of the 1933 eighth-grade class of Bain School: (first row) Dolly Cochran, Jean Davis, Hazel Brafford, Jim Black, Ruth Mullis, Lloyd Long, Elizabeth Williams, and Dot Williams; (second row) Maurine Whitley, Virginia Hinson, Mary Thomas, Catherine Braswell, Mary Todd, Mary Etta Phillips, Yates Flowe, and Emma Lou Benton; (third row) Mabel Mullis, Clinton M. Black Jr., Willene Simpson, Ruth Rice, Patsy Morris, Annie Mullis, unidentified, and Virginia McManus; (fourth row) Margaret Garmon, J.R. Mullis, Ed Ellington, James Benton, Horace Medlin, J. Dowd Henderson, Elizabeth Flowe, and Lucille Connell; (fifth row) Lloyd Flowe, Ellis Bostic, Dolph Black, Robert Phillips, Principal D.W. Coon, Clem Williams, Louis Cox, Alma Eudy, and Audie Mullis.

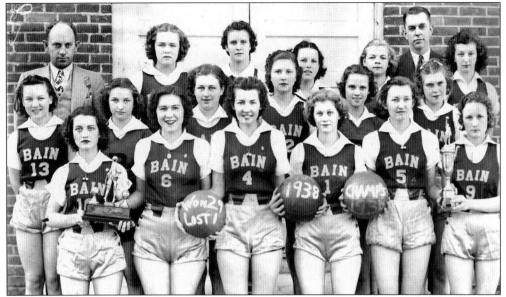

In 1938, the girls' basketball team at Bain won the Mecklenburg County Championship. Pictured here from left to right are (front row) Frances Forbis, Ruth Haigler, Helen McEwen, Dot Mullis, Bettie McEwen, and Margaret Wilson; (middle row) Sue Allen, Elnora Moser, Edith Beaver, Mildred Dulin, Judy Flowe, and Edna Ferguson; (back row) Principal A.E. Harrington, Edith Haigler, Eddie Mullis, Ruth Hood, Rose Alice Henderson, Coach B.W. Griffith, and Johnsie McWhirter.

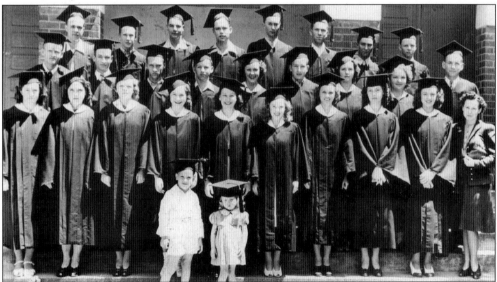

In this picture, mascots Jerry Thompson and Frances Phillips stand in front of the Bain High School graduating class of 1941. Members of the class, from left to right, are (front row) Margie Mullis, Blanche Ferguson, Rosealyce Henderson, Elnora Moser, Sue Allen, Eloise Lemmond, Judy Flow, Thelma Phillips, Tharza Vaughn, and Mrs. ? Coffee (teacher); (middle row) Ralph Moser, J.Z. Benton, Carl Jordan, Hal Brafford, Edith Haigler, Aubrey Bartlett, Mildred Dulin, Lorraine McWhirter, and Bruce Thompson; (back row) Zeb McManus, Hubert Williams, Ted Mullis, Harlan Bartlett, Carlton Long, R.B. Rowell, Rayvon Ferguson, and Ned Brafford.

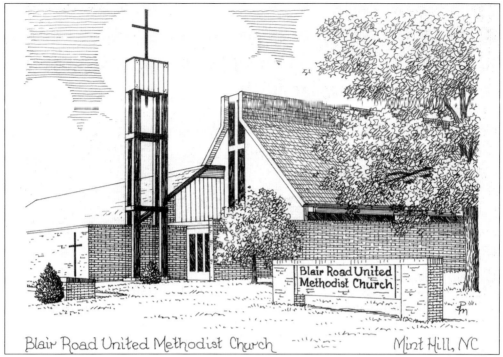

Blair Road United Methodist Church — Mint Hill, NC

Blair Road United Methodist Church was organized in 1958, with eight families meeting for the first service in the home of William Elliotte on Blair Road. In 1959, R.L. Poindexter became the first minister. Through the years, additional property and new buildings were constructed to accommodate the church's steady growth. Today Blair Road flourishes with their outreach, education, and youth programs.

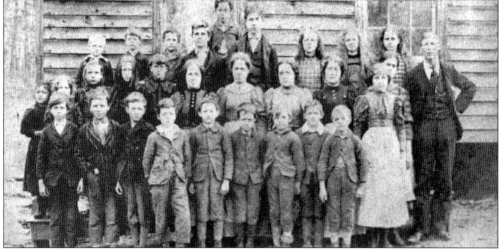

It's not known exactly when the Ashcraft Schoolhouse was built, but this student picture, which includes teacher Dallas Fink, is dated 1895. School board ledgers from 1902 recorded that Walter Junker earned $30 a month for teaching. The Ashcraft Schoolhouse probably closed sometime in the 1920s when the county began a consolidation effort for fewer, larger schools. The schoolhouse was donated to the historical society by the Linker family and is currently being restored at the Carl J. McEwen Historic Village.

Mable Black Byrum attended Henderson Grove Elementary and graduated from Clear Creek High School in 1949 with the following classmates, from left to right: (first row) mascots May Scott and unidentified; (second row) Hattie Lee Stafford, Annie Conner Reynolds, Lula Ellie D. Lawrence, possibly Deloris Hemphill, Pecola Abraham, and Sarah Rose Alexandro; (third row) Mable Alberta Flowe, Florence Virginia Wallace, possibly Delores Hemphill, Stella Mae Singleton, and Sadie Morris; (fourth row) Emma Dorothy Scott, Mary Ruth Coleman, Mable Alberta Black (Byrum), Earl King Maxwell, and Orangie Coleman; (fifth row) Charles Lee Helton, Jephra Phillips, and Joseph Lee.

Pictured here from left to right are students from Bain's ninth-grade class in 1945: (first row) Dorothy Connell, Doris Honeycutt, Josephine Long, Mary Williams, and Rachel McCall; (second row) Carolyn Carriker, Nancy Lee, Betty Scott Thompson, Bernice Thompson, and Libby McManus; (third row) Margie Hough, Doris Mullis, Edith Williams, and Annie K. Carriker; (fourth row) Donald Huntley, Bill Hood, Brady Carriker, Jack Baucom, and Gene Griffin; (fifth row) Merl Ferguson, Benny Davis, Doug Ross, Ed McWhirter, Harry Wilson, Lee Flowe, and Yates Phillips.